a place
in the sun

a place in the sun

photographs of los angeles by

John Humble

with essays by

Gordon Baldwin

The J. Paul Getty Museum, Los Angeles

This publication is issued in connection with the exhibition
A Place in the Sun: Photographs of Los Angeles by John Humble, held at the
J. Paul Getty Museum, Los Angeles, March 27–July 8, 2007. The Photographs Council
of the J. Paul Getty Museum generously supported this publication.

Published by the J. Paul Getty Museum, Los Angeles
Getty Publications
1200 Getty Center Drive, Suite 500
Los Angeles, California 90049-1682
www.getty.edu

Mark Greenberg, *Editor in Chief*

Library of Congress Cataloging-in-Publication Data

Humble, John (John Kenneth), 1944–
A place in the sun: photographs of Los Angeles / by John Humble;
with essays by Gordon Baldwin.
 p. cm.
"This publication is issued in connection with the exhibition A Place
in the Sun: Photographs of Los Angeles by John Humble, held at the J.
Paul Getty Museum, Los Angeles, March 27–July 8, 2007"—Pref.
Includes bibliographical references.
ISBN 978-0-89236-881-5 (hardcover)
 1. Los Angeles (Calif.)–Pictorial works—Exhibitions. 2. Humble,
John (John Kenneth), 1944—Exhibitions. I. Baldwin, Gordon, 1939– II.
J. Paul Getty Museum. III. Title.
F869.L843H86 2007
979.4'940540222—dc22
 2006033016

Front cover: Detail of *Headwaters, The Los Angeles River, Confluence of Arroyo Calabasas and Bell Creek, Canoga Park, 2001* (pl. 21).

Back cover: Detail of *View South from Recreation Road, Carson, May 2, 1980* (pl. 1).

Title page: Detail of *The Los Angeles River from Main Street, Los Angeles, 2001* (pl. 28).

Endpapers: Map © by Rand McNally, R.L.06-S-143.

Contents

Foreword

Since 1974, John Humble has documented greater Los Angeles, creating pictures that walk a fine line between the subtle and the obvious. His desire to capture what he calls "the incongruities and ironies of the Los Angeles landscape" has resulted in a vibrant body of work that journeys through the built environment and diverse neighborhoods of the city. Humble's photographs reveal Los Angeles as not just an eternally balmy place in the sun. He depicts a complicated metropolis that, like so many great American cities, includes elements of sadness and decay—elements that the J. Paul Getty Museum, like any good citizen, is committed to explore and understand.

A project such as this involves the collaborative effort of many individuals. I am especially grateful to the Photographs Council of the Getty Museum for supporting this publication; in particular, thanks are due to the members of the Council's Publications Committee, who gave generously of themselves to this project. John Humble graciously opened his entire archive for review, a process that was coordinated by his dealer, Jan Kesner. We are indebted to both for their time and talents. Gordon Baldwin tapped into his long-held interest in the built environment of Southern California to provide the literary and historical background to the photographs. In the Department of Photographs, Weston Naef and Judith Keller shared a dedication to the project that ensured its evolution from the proposal stage to the finished publication. Anne Lyden ably coordinated both the publication and the exhibition; Anne Lacoste negotiated the complexities of the visual documentation; and Brett Abbott and Karen Hellman efficiently facilitated the loans from private collections. This book was made real by the diligent efforts of Getty Publications, notably Mark Greenberg, John Harris, Stacy Miyagawa, Deenie Yudell, Jesse Zwack, and independent designer William Longhauser. To them all, my sincere thanks.

Michael Brand
Director
J. Paul Getty Museum

Detail of *600 Shields Drive, San Pedro, September 12, 1992* (pl. 6).

Presented by

Y FAMILIA

Casablanca"

MKT.

1026 S. Indiana Street Los Angeles Calif. 90023

COLD·Beer
SoDa's
CANDY

BUY IT HERE
Los Angeles
TIMES

oup
9's
Tillas

SLUSH
PUPPI

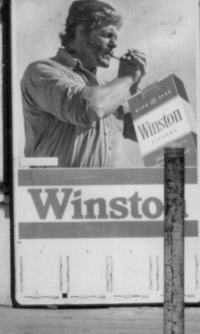

An Essential Humanity

Gordon Baldwin

The twenty vibrant photographs of urban scenes in Los Angeles that make up this section of this book and the larger body of work from which they are drawn are the striking, tangible manifestations of John Humble's fascination with the visual textures of widely scattered places in the California metropolis that he has discovered but that would have to be deemed, with rare exceptions, obscure.[1] What he calls his urban landscapes are part of Humble's long-term photographic effort to come to grips with a city that is a notoriously slippery subject because of its scale and diversity.

Somewhat loosely defined subsets within Humble's Los Angeles work, all of which is in color, include an early group of images of the freeways and a later, larger group of studies of these roadways at night. Another category comprises impromptu portraits of a variety of Angelenos, including construction workers, East L.A. gang members, a Hispanic family at the beach, and a couple in wedding finery on a downtown sidewalk. Some more recent pictures look seaward from a lifeguard station on the beach in Santa Monica but—despite their having been made in the region—these are best considered as separate entities. There is the group of images of the Los Angeles River that are the subject of another section of this book, and a new and ongoing project documenting the deserted streets of the industrial districts on Sunday afternoons. In surprising contrast to the subjects of his California work, the artist is also currently making photographs of churches on the Eastern Shore of Maryland.

These distinctive photographs have been created over a period of many years, beginning in 1979, five years after Humble moved to Los Angeles and shortly after he shifted from 35mm black-and-white film to four-by-five color film. His carefully composed studies of the urban fabric are antithetical to conventionally upbeat or glamorous pictures of the city. Instead, through these images, which often detail incongruities of structure or environment, the photographer moves toward establishing a unique aesthetic of his own, a perhaps difficult beauty, but one that is firmly based in actualities of place and time. The photographer makes this grounding clear by invariably titling these images with a street address or the name of the nearest intersection and, often, the direction in which the view was made. The inclusion of these specifics is perhaps not surprising in a city so consecrated to the automobile and whose inhabitants (including, one assumes, the photographer) are often preoccupied with what route they took and how much time is needed to reach a given place. The temporal foundation of the work is made clear by his inclusion of the day, month, and year the exposure was made as essential components of his titles. (His specificity does not extend, however, to noting time or temperature.) John Humble's photographs are about reality, not fantasy, even if he once titled a college course that he was teaching "Photographing Paradise."

Although the sites and structures depicted in these images are disparate, joined only by the eye and intelligence that saw and sought to record them, and by their having been gathered together in this book, they have a communality that can be discerned and described. One of the unifying factors of this ongoing series is the omnipresent sky, whether lightly veiled with cloud, distempered at the horizon by pollution, suffused with gold in the late afternoon, or blazoned with cobalt at midday. And, indeed, it is the changing light of Los Angeles that is, at least to some, the city's most salient feature. In the photographs of the Los Angeles River, the sky becomes an actor with a larger, more dramatic and varied role, but in Humble's urban landscapes it is more

Detail of *1026 South Indiana Street, East Los Angeles, June 26, 1986* (pl. 11).

shifting mise-en-scène than principal player. Humble does not apply filters to his camera, and as a result the subtle shading of the sky from its upper to lower edges remains evident and scoops out its concave contour; it is not a flat backdrop.

Many of these pictures have as their subjects stand-alone, homely, residential or commercial structures that are exemplars of regional vernacular architecture. Because they are photographed straight on and are often centered in the frame, these images can be considered distinctly documentary in nature, although they consistently transcend that genre. Whatever their functions, these buildings have no architectural pretensions and may be taken as exemplary of the actualities of Los Angeles as it is.

These modest structures and their immediate surrounds often sport advertising signage of widely differing levels of graphic sophistication, from the hand-painted, which is perhaps more decorative than informative, to the mass-produced, which is predictably bland and banal (pls. 4, 5, 7, 9, 10, 11, 13, 14, 17). Food, liquor, automobiles, and cigarettes predominate, but what is being advertised, whether in English or Spanish, also extends from modest commercial activities on the premises to more elaborate ventures elsewhere. The latter are often trumpeted on large-scale billboards, frequently erected in uncomfortably close proximity to houses. The superbly eccentric and visibly aging sign for a mom-and-pop hamburger stand, of the kind that is rapidly disappearing from the Los Angeles scene, is the subject of one engaging image (pl. 17).[2] Both the sign's strident red, which is reinforced by the presence in the image of three red vehicles and two red signs for gasoline, and its unique shape, differentiate it from more prosaic advertising found elsewhere.

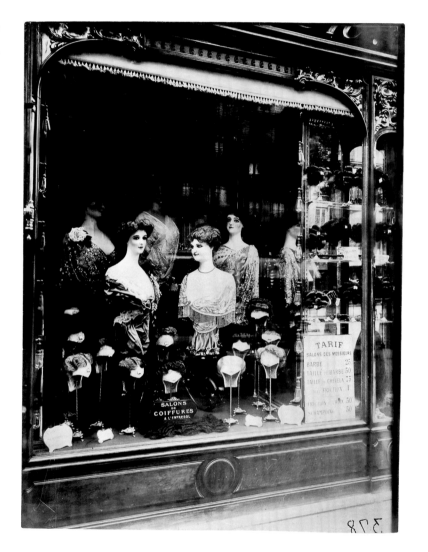

It has been said, perhaps more cleverly than accurately, that Atget's urban images, which like Humble's constitute an idiosyncratic urban survey, look as if they are the scenes of crimes already or about to be committed.[3] Given the history of noir fiction and film in and about Los Angeles, it might be tempting to try to read Humble's pictures of this city in similar fashion, but several factors weigh against such an interpretation (even if he recently allowed one of his photographs to

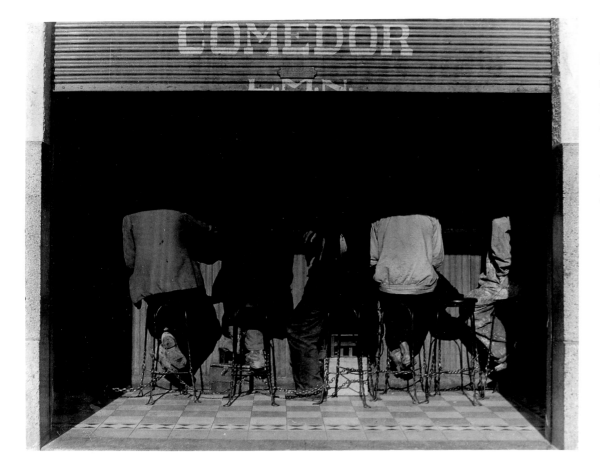

hamburger stand indicates (pl. 7), with three people on the street and one at a counter. Yes, there is a resemblance here to Atget, but it is not in moody atmospherics but rather in the concentration on store-front display (opposite page).[5] In the Los Angeles shop there are two rows of headless female mannequins, each of which is split mid-torso: the upper row shows swimwear or undergarments to be worn below the navel and the lower row those to be worn above the navel. (At the adjoining hamburger stand, the back of a seated man at the counter should not be taken as an overt reference to similar figures in a photograph by Manuel Alvarez Bravo [at left].) This densely layered composition—in which at least four spatially receding levels of buildings have been vertically stacked and compressed as if they existed on a single plane—was made possible because the camera was placed in an elevated position so that the view extends above and beyond the foreground store and stand.

One of Humble's most compelling pictorial strategies is to contrast a principal foreground element, which is often residential, with a background element that is wholly different, usually industrial. An example of this kind of juxtaposition, which can perhaps be characterized as surreal, is the photograph of a tiny, isolated house at the end of a dead-end street in San Pedro. This urban orphan is played against a sweep of distant freeway, with oil storage tanks along the horizon (pl. 6). The pristine, scalloped edges of the yellow-painted door and window frames are sweetly domestic, wholly unlike the hard orange diamond of a nearby sign or the grime (and noise) of the freeway and distant industrial structures. (His view of a bar advertising pool tournaments and televised sports captures another forlorn, freestanding building, but he hasn't employed this one to challenge its setting [pl. 10].)

be reproduced on the cover of a police thriller by Michael Connelly).[4] Although he is a reader of Connelly, Raymond Chandler, James Ellroy, and T. C. Boyle, there is a complete absence of sinister shadows and altogether too much California sunlight, as opposed to Paris gloom, for these pictures to have ominous undertones, except perhaps occasionally from an environmental point of view. The color in these pictures, which is often bright, even cheerful, also militates against downbeat interpretations.

Humble is a persistent and perceptive observer of the city, as well as a good-natured one, as his picture of a lingerie store and a next-door

John Humble
Monsoon Lagoon, Redondo Beach, August 28, 1992.
Chromogenic print, 50.8 × 61 cm (20 × 24 in.).
Collection of Michael and Sharon Blasgen.

Another work that embodies a tension between its principal elements is one of Humble's earliest color photographs and his third to be made with a view camera (pl. 2). Taken in 1979 at a trailer park in Torrance, it shows high-voltage electrical transmission towers and power lines looming over a low-lying trailer home and its minimal, perhaps new rather than stunted, garden. By comparison to the steel lattices overhead, the telephone poles in the background at the right seem innocuous and the row of upright Italian cypresses at the left benevolent. The height of the towers is emphasized by the vertical framing of the composition, which is anchored at its base by the black bands of asphalted street and driveway. A related example of a foreground-background disjunction of environments is a lively view of an aquatic park set under and against a forest of power lines (opposite page).

A third photograph to play foreground against background pits the squat, essentially cubic, forms of two small apartment complexes, of the kind often referred to as bungalow courts, against two massive cylindrical storage tanks behind them (pl. 8).[6] In the front yard of one complex, a man in a plaid shirt seems more intent on checking out the photographer than on watering the evidently neglected lawn: his head is turned toward the camera and the stream of water from the hose arcs ineffectually high. When on the streets, Humble tries to be inconspicuous in order to avoid confrontations with either inquisitive bystanders or (increasingly) officious police officers. But invisibility is difficult to achieve if, as he did here, he sets up orange cones to protect his camera on its tripod in the street. The image is an example of Humble's adroit sense of how to compose a picture. He lined up one side of a slender foreground streetlight pole, which runs from the top to the bottom of the photograph, with one edge of the entry

arch of the nearer bungalow cluster, while lining up the other side of the pole with a subsidiary arched opening in the same wall. By being thrust forward in contrast to its sunlit background, the light pole is given more visual weight; the picture is balanced by its placement at the same distance from the left edge of the photograph as the storage tanks are from the right. As is often the case in Humble's pictures, wires create geometric forms. Here, a square of sky is divided by a wire that runs diagonally from the top of the left tank to the place where it intersects the apartment roofline. Others horizontally bisect the page.

A more conceptual kind of contrast occurs in those photographs where Humble positions mundane gritty industrial elements in the foreground and the sleek polished skyscrapers of downtown Los Angeles in the background (pls. 3, 16). Aside from the differing surface textures that are being compared, there is perhaps a philosophical point being made about the means and circumstances by which wealth is created and the ways in which wealth is manifested. No Oz, this: the towers of the central city have risen, at least in part, because of the grubby industry that surrounds them. Even without this sociological consideration, these two pictures are worth examining in detail for the way in which the photographer has structured his compositions. In the view west from Myers Street (pl. 3), the bold diagonal of the bridge balustrade, which carries a string of lampposts of diminishing size, directs us to an irregular block of skyscrapers silhouetted against the summer smog. It sits on a layered stack of bank buildings of smaller scale, brick warehouses being converted into lofts, a silver commuter train, graffiti-embellished walls, and the foreground train tracks. The Los Angeles River is an invisible presence, out of view beyond and below the nearest wall. Characteristic of Humble's attention to detail, the left

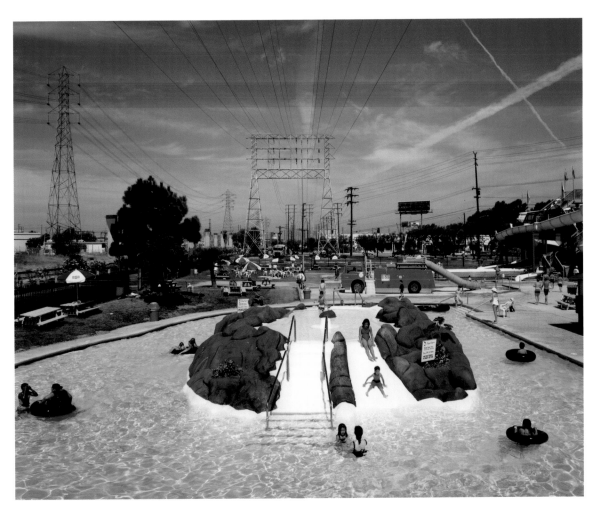

edge of the photograph is exactly parallel to the vertical lines of the rising pylon that supports the adjacent sections of the bridge, and the lowest wire meets the pylon at the diagonal of the railing. In the view west from Commercial Street (pl. 16), railroad tracks embedded in the street appear to be tire marks that were laid down by the pickup truck. Felicitously, which is to say in Humble's images, intentionally, its brake lights were red at the instant of the exposure, although it has already overshot the stop sign. The image is rich with a variety of vertically striated surface textures that are countered by the horizontal repetitions of the telephone-pole cross bars, the transverse street at the intersection, and the overhead electrical cables that stretch across the picture plane.

One of the consistent pleasures in examining Humble's pictures is the frequent inclusion of odd, attention-getting details, like the brake light. Other such incorporations sometimes pose questions about the past or present uses of the buildings that are depicted or the predilections of their users. In plate eleven (see detail on p. 8), the text of the storefront sign seems to have an internal, perhaps unintended, elision or conflation of the verbal and visual, so that Bogart and Bergman

become the Casablanca family whose market this then must be. And what possible purpose do the words "Los Angeles Calif." and the zip code serve? (The apostrophes in the words "soda's" and "egg's" are more familiar textual oddities, while "slush puppie" is an interesting coinage.) Not to be overlooked is the man in the shadow of the porch, ensnared by the camera just as he is about to enter a house. These photographs bear, as they say, close examination.

In plate twelve, Humble's invariably careful pictorial structure elevates an image of a humdrum house on Gage Street in Bell Gardens from the merely anecdotal to the geometrically precise. The stanchions of a billboard at the right, a square wedge of concrete block at the left, and a web of wire overhead severely constrict the facade of the house. Exact lateral camera placement made it possible not only to center the building on the page but also to line up the billboard stanchion farther from the street with the right edge of the building. The cables emphatically and precisely slice from corner to corner across its front, another instance of the photographer's consistent use of wires as compositional elements. The concrete wall at one side, the ill-fitting security grill that obscures the street number of this house, and the evidently recent shrinkage of the window emphasize the building's embattled state, which is aggravated rather than ameliorated by the vase of plastic roses on the windowsill (p. 14). These flowers are what Roland Barthes would have denominated as the punctum of the photograph;[7] Humble more straightforwardly describes them as the visual magnet that drew him into the scene.

Intentional and blatant visual magnets are the bikini-clad model and the advertising slogan that tout the Sands casino in Las Vegas as "A place in the sun" on the most prominent billboard in the image

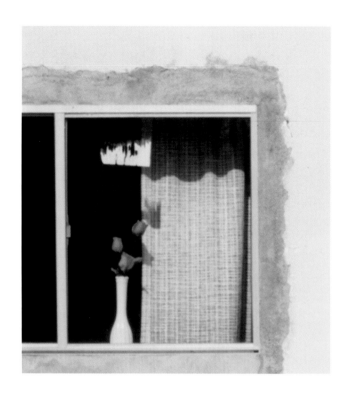

the tip of one of the flagpole/lighting fixtures on the car lot. When he had finished setting up his photograph, the opportune arrival of the man who settled into the folding lawn chair in the left foreground gave Humble the opportunity to add an enlivening detail. However diminutive, this addition to a quintessentially American image embodies what Humble, who cites Henri Cartier-Bresson as an influence, calls a decisive moment. Other examples of such inclusions produced by patience and timing occur whenever pedestrians or automobiles with drivers appear in the images (see pls. 4, 5).

A set of photographic urban landscapes of a city whose reputation is indissolubly linked to its freeways would be incomplete without a picture in which a highway is the principal subject (pl. 20). Humble has made two substantial groups of such studies. The one included here depicts the I-105 Freeway, the last to be finished, and probably the last ever to be constructed.[9] Nineteen miles long, it was two years away from completion when Humble made his 1991 sundown study of truncated ends and complex interweavings at its towering intersection with the Harbor Freeway, an older and more important artery, which recedes northward into the distance at the left. Horizontal bands of roadway frame a distant view of downtown Los Angeles that is seen through a layer of lavender haze in a picture that is permeated with golden light. In contrast to the heaviness of the concrete foreground, light clouds drift across a robin's-egg-blue sky soiled by pollution.

Humble's achievement in the urban landscapes can perhaps best be summarized by saying that the series is made up of multiple transformations of the mundane into the beautiful. The photographs have been made possible by his recognition of the aesthetic potential of

in plate one. That phrase and the image of the young woman may also be an intentional reference to the opening sequence of the 1951 talismanic film of the same name, in which Montgomery Clift is shown hitchhiking in front of a highway sign that advertises swimsuits.[8] In Humble's photograph, a subtle vertical adjustment of the camera made it possible for the artist, quite consciously, to include the text of a sixth billboard in the image. The words "wildly exciting," which surely do not apply to their context, can be made out on a highway sign that is visible in the tightly compressed space between the bottom of the advertisement for "Amerec Subaru" and the top of the one for "Amerec Leasing" (see detail on back cover). These words could not have been seen, nor could the receding perspective of the parked cars have been established, had Humble not been photographing from an elevated position, a vantage point he favored and frequently achieved by positioning himself and his tripod-mounted four-by-five camera atop a reinforced plywood platform affixed to the roof of his Volkswagen van.

A slight lateral shift permitted Humble to attach the image of a man's head on a billboard on the other side of the neighboring freeway to

seemingly ordinary sites, to which he has applied adroit framing strategies and his overall compositional genius. This entails the ability to play horizontal and vertical elements against each other and by exact camera placement to establish carefully weighted balances of pictorial elements across the surface of his pictures. His superb color sense encompasses hues from the delicate to the bold and lets him recognize and extract both from the scenes he so diligently seeks. A somewhat rueful—rather than ironic—humor seems to underlie many of these pictures, and that too contributes to the essential humanity that makes these photographs both accessible and important.

1. An exception is the arresting photograph, a print of which is in the private collection of Leonard Vernon, of the now much modified Capitol Records building in Hollywood and a mural painted on it.

2. And, in fact, this little eatery no longer exists.

3. It was Atget's invariable habit to inscribe on the versos of his photographs the addresses where they were made, and Humble, as noted, does something similar. The two photographers are distinctly different in that Atget moved about on foot in his obsessive visual pursuit of a much smaller city. Humble traverses his territory in a vehicle and has been more selective and less comprehensive in what he chooses to photograph.

4. Michael Connelly, *The Closers* (New York, 2005). Discussing the specific resemblances of the places in Humble's photographs to scenes in the nearly endless cinematic depictions of Los Angeles, ranging from *Day of the Locust* to *Chinatown* to *L.A. Confidential* to *The Black Dahlia*, is beyond the scope of this essay.

5. The French word for this sort of display is *étalage*, and examples of it are found throughout Atget's work.

6. These small-scale apartments, each with its own front door and grouped around a narrow, U-shaped courtyard, often have a fringe of red tile at their rooflines and over their doors or windows. The type has a long Los Angeles history: it originated before World War I and particularly flourished in the 1920s. The term *bungalow court* is something of a misnomer, as true bungalows have low-pitched rather than flat roofs and are independent of one another. My thanks to Ken Breisch for sharing his knowledge of Los Angeles architecture with me.

7. See Roland Barthes, *Camera Lucida* (New York, 1981), 26ff.

8. George Stevens's Oscar-winning film also starred Elizabeth Taylor and Shelley Winters. It was based on Theodore Dreiser's 1925 novel, *An American Tragedy*, a subsequent stage treatment of the same story, and a Josef von Sternberg film of 1931 that utilized the same plot.

9. Environmental concerns, the substantial political costs of displacements caused by the exercise of eminent domain over myriad properties, and the staggering expense of actual construction all militate against the addition of new freeways to the existing network. The I-105 Freeway (usually referred to as the Century Freeway but actually named the Glenn M. Anderson Freeway to honor a congressman who secured the funds to build it), was first announced in the late 1960s but was not opened until 1993.

PLATE 1 *View South from Recreation Road, Carson, May 2, 1980*

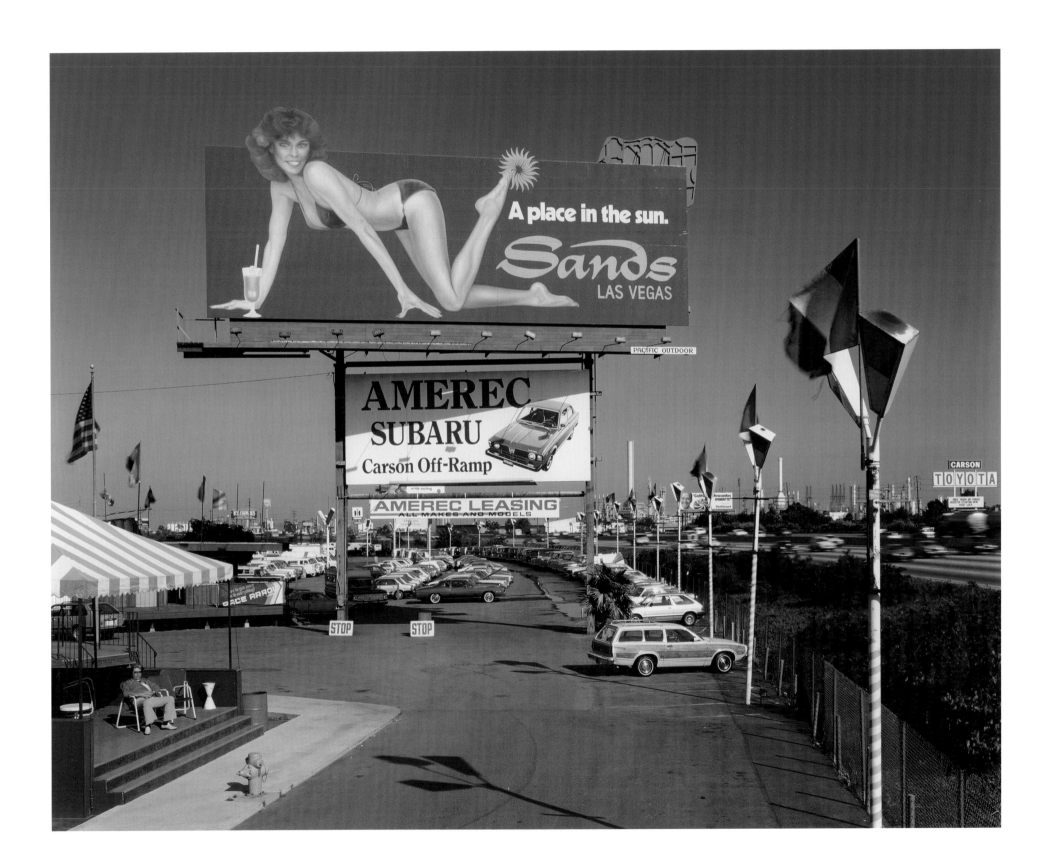

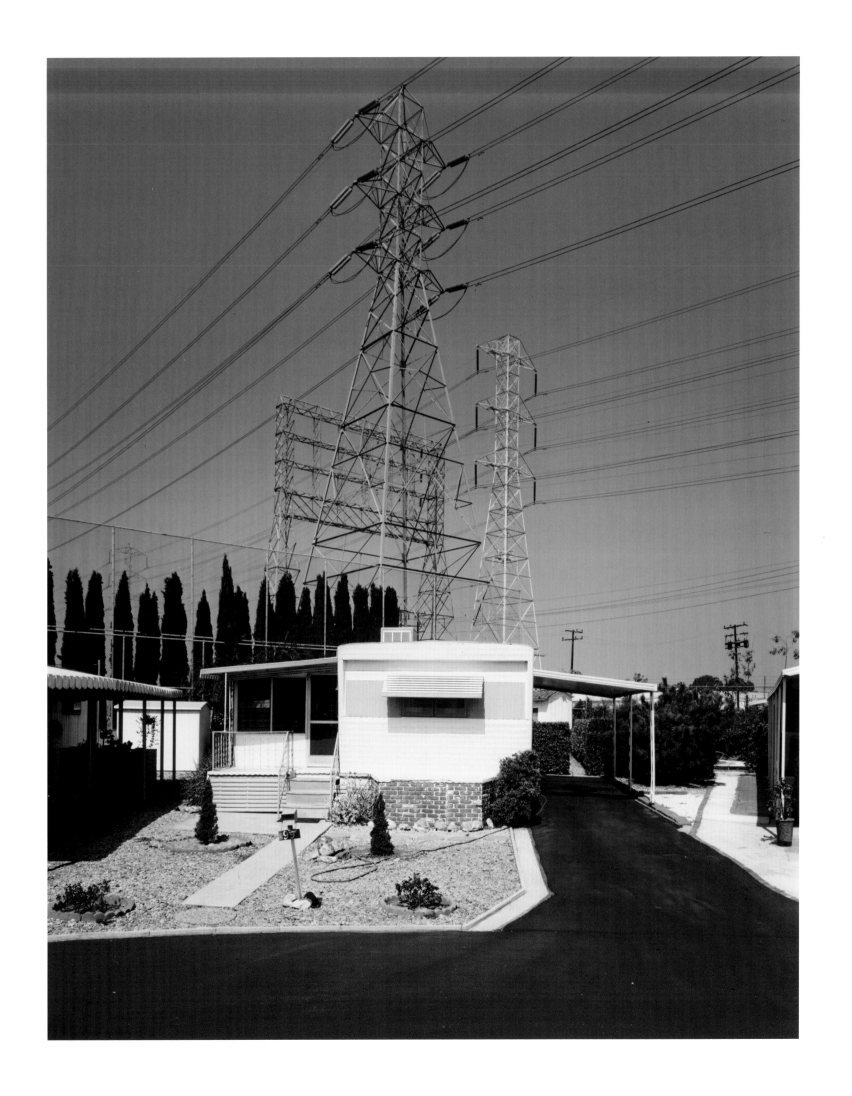

PLATE 3 *View West from 100 Block Myers Street, Los Angeles, June 17, 1992*

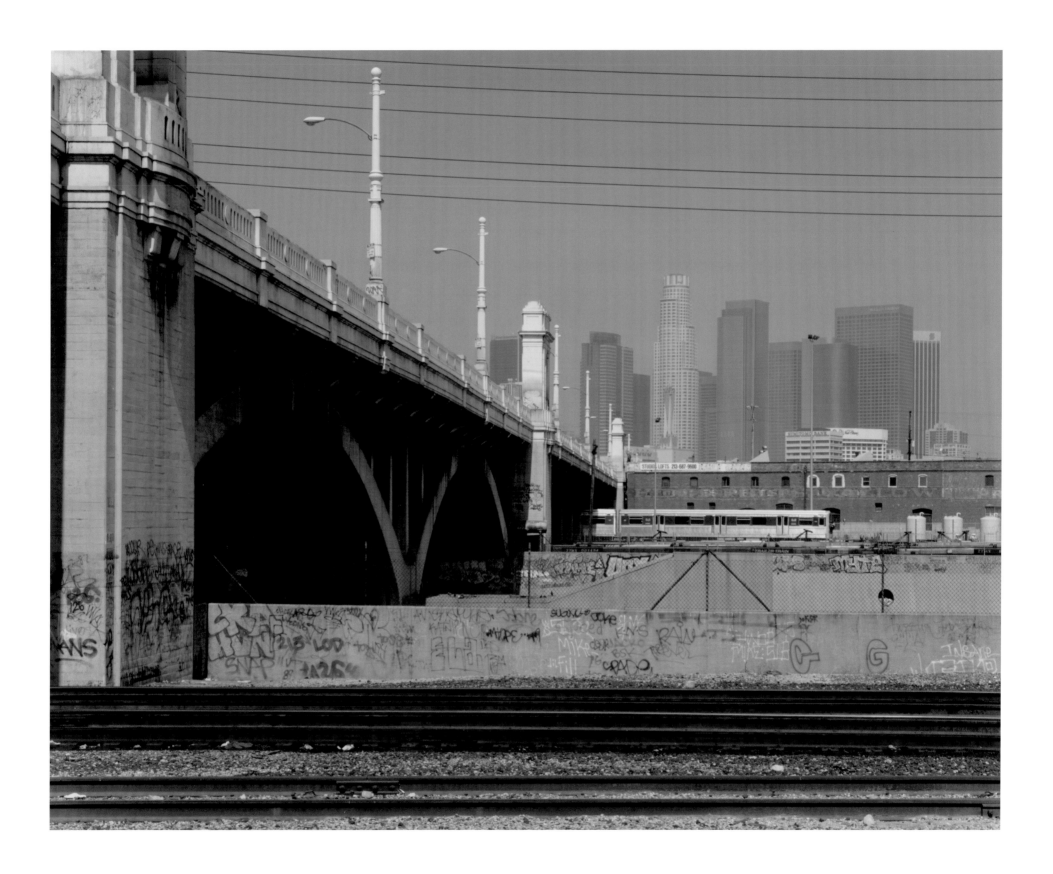

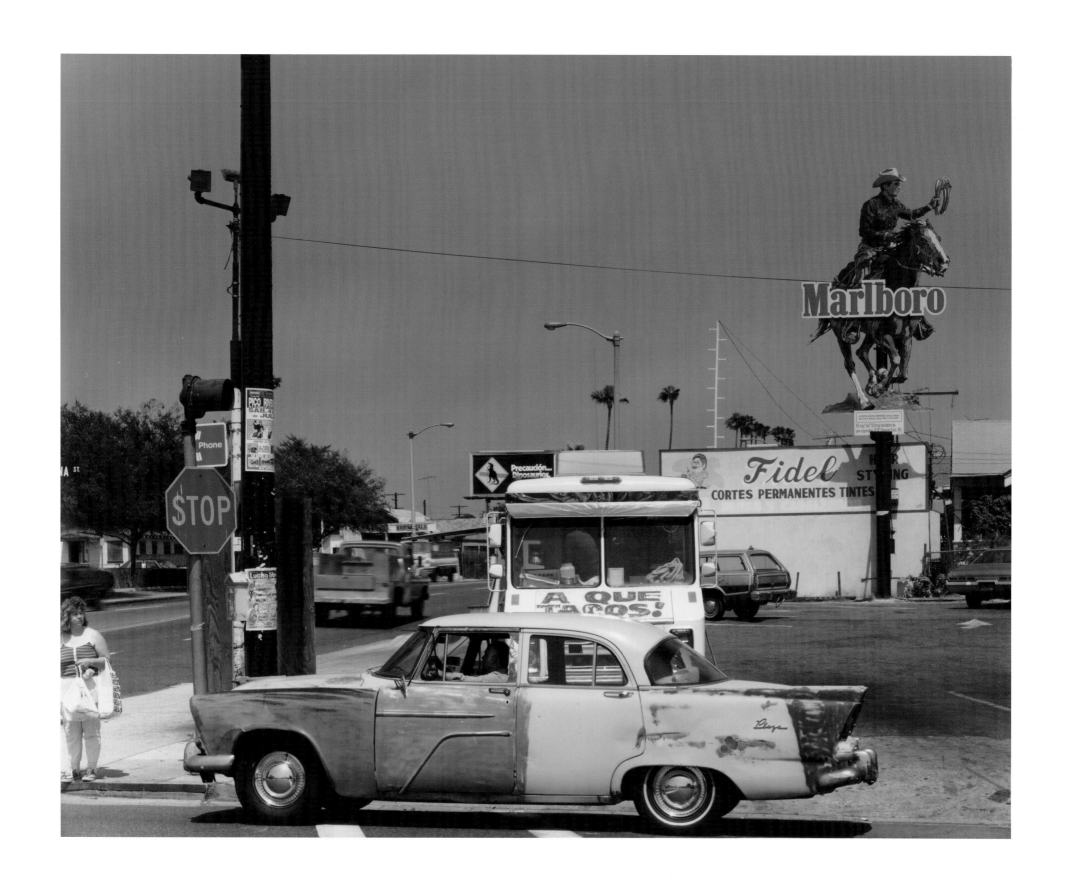

PLATE 4 *Indiana Street at Brooklyn Avenue, East Los Angeles, June 26, 1987*

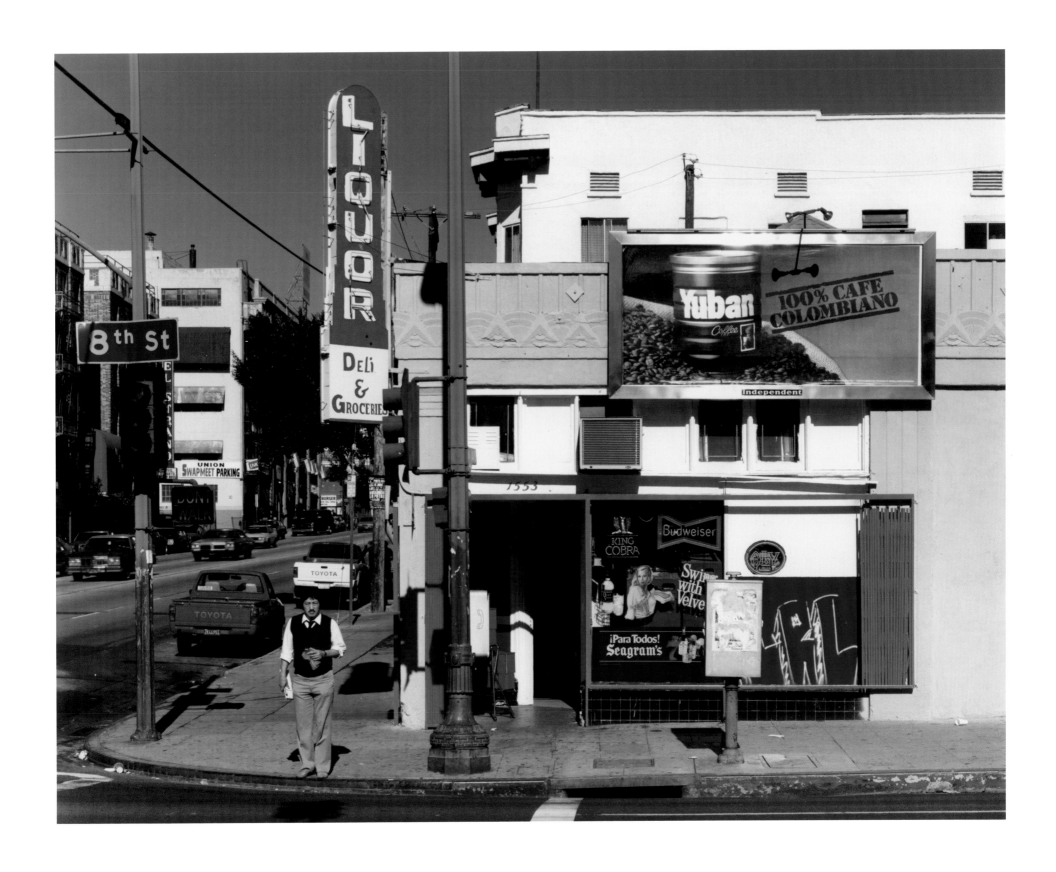

PLATE 5 *1553 8th Street, Los Angeles, November 15, 1985*

PLATE 6 *600 Shields Drive, San Pedro, September 12, 1992*

24 | 25

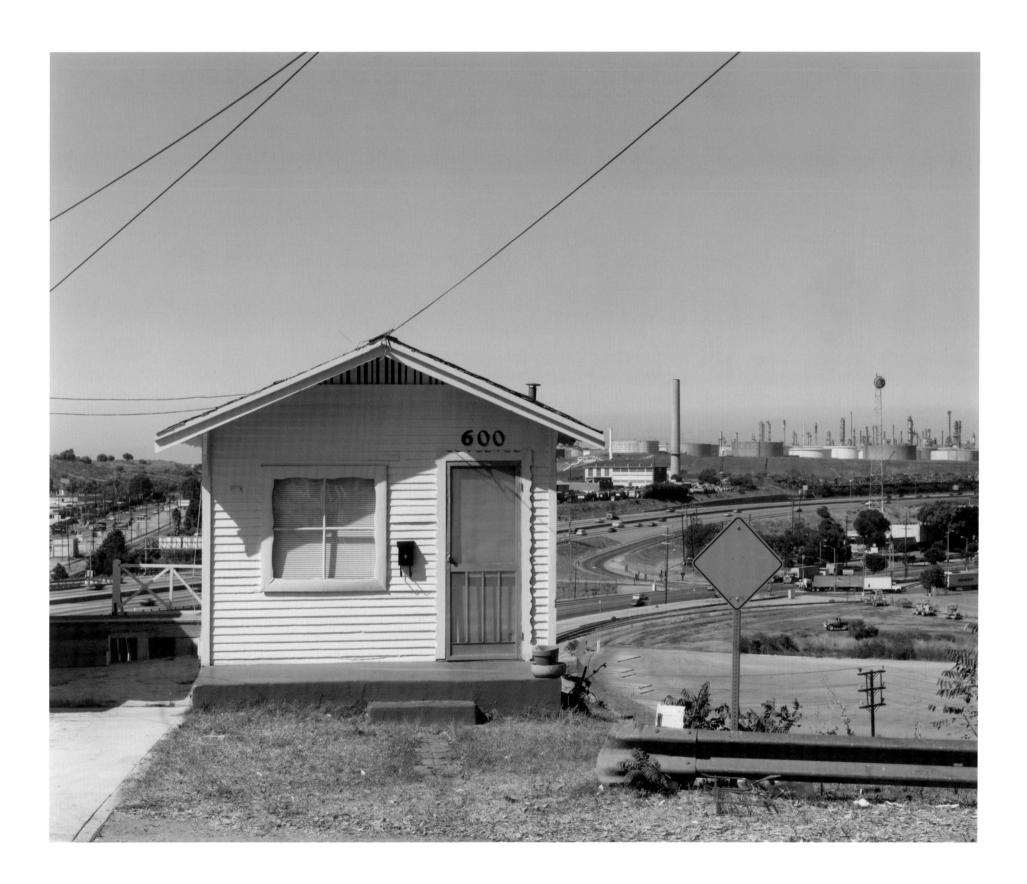

PLATE 7 *100 Block of 7th Street, Los Angeles, October 3, 1980*

26 | 27

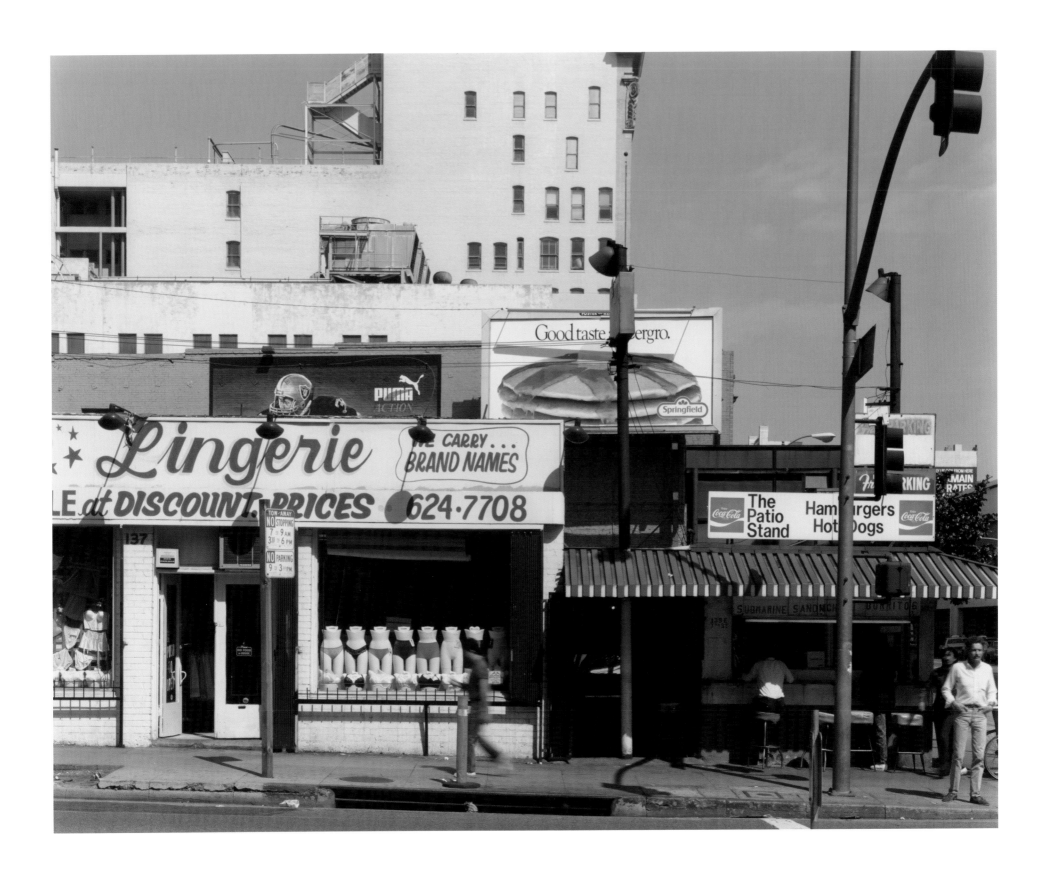

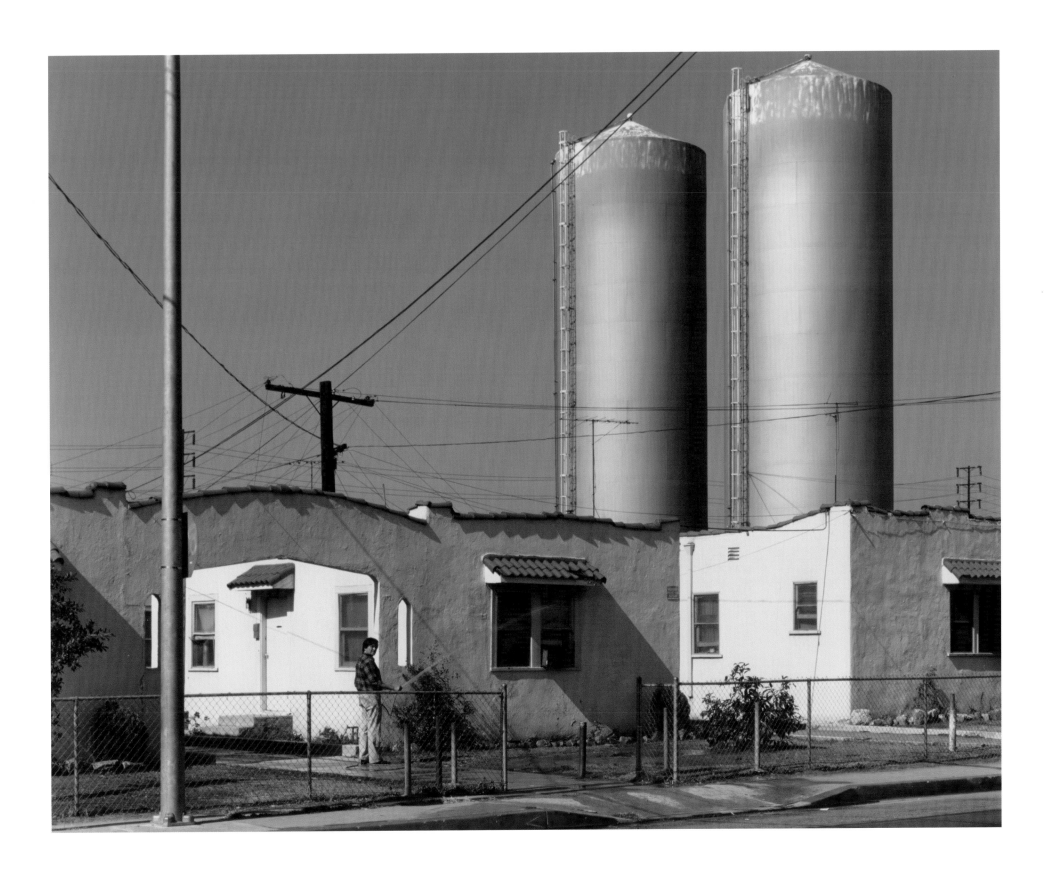

PLATE 9 *719 Lincoln Boulevard, Venice, May 13, 1995*

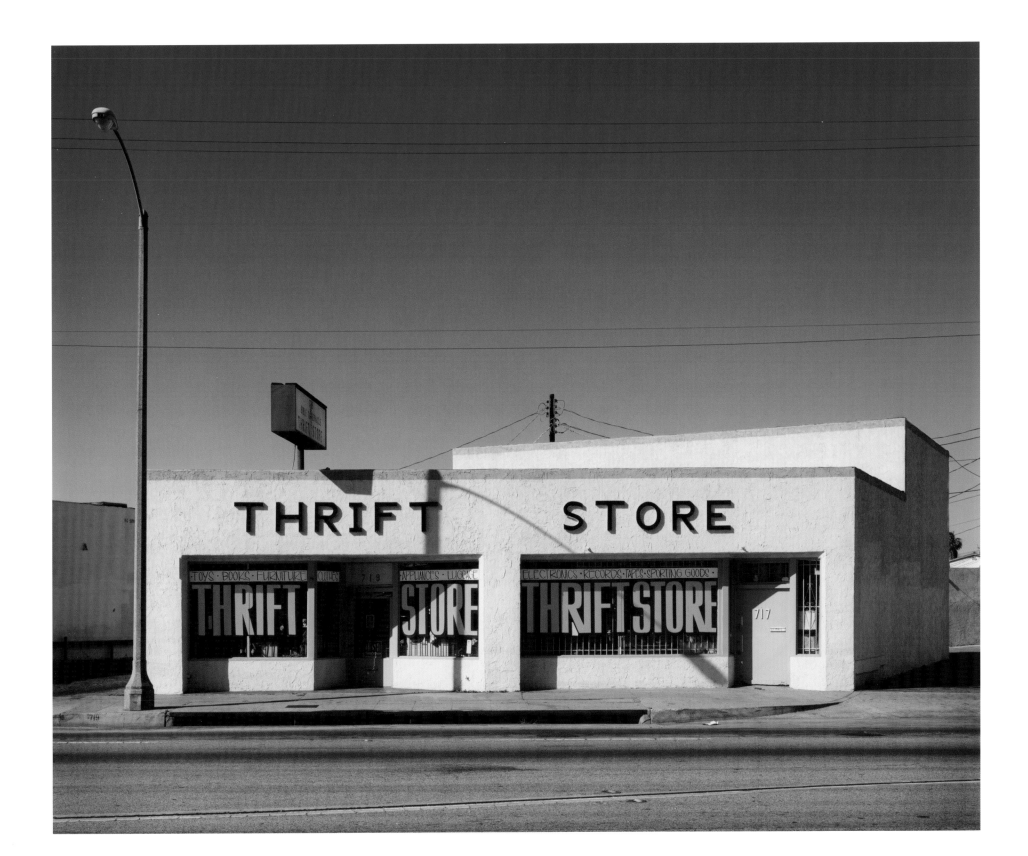

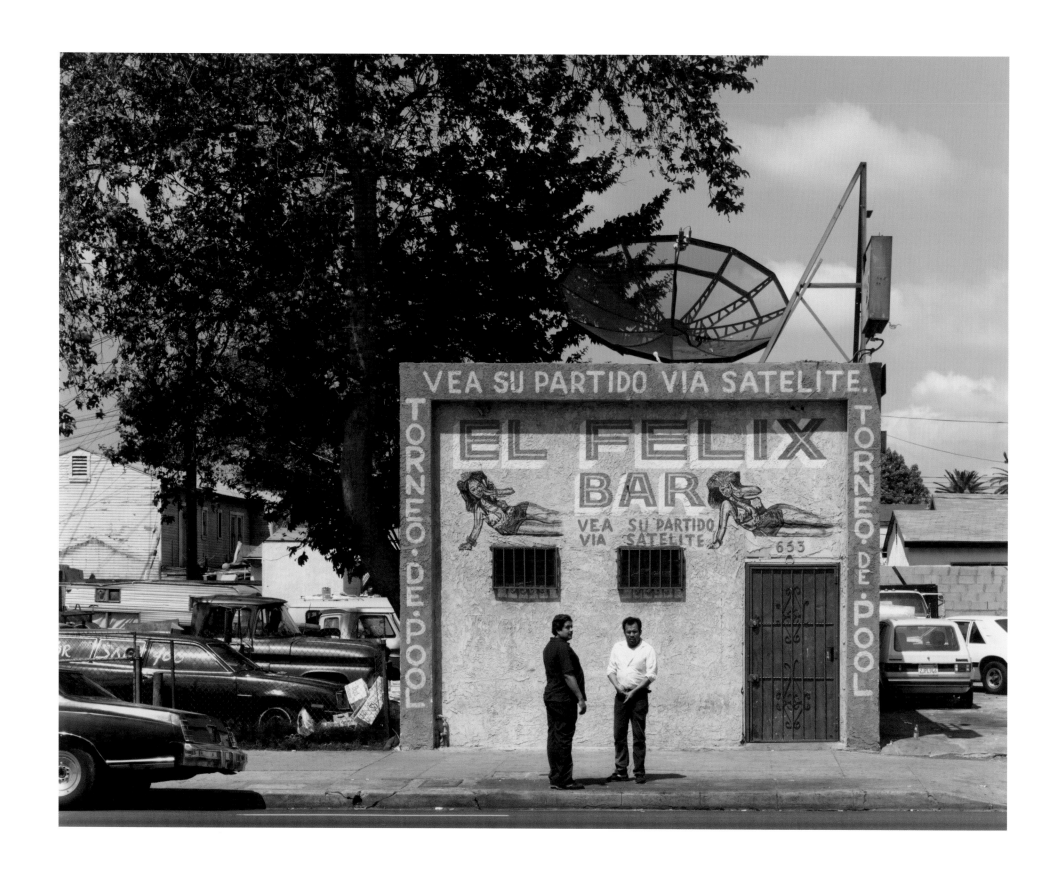

PLATE 10 *653 Florence Avenue, Los Angeles, April 8, 1990*

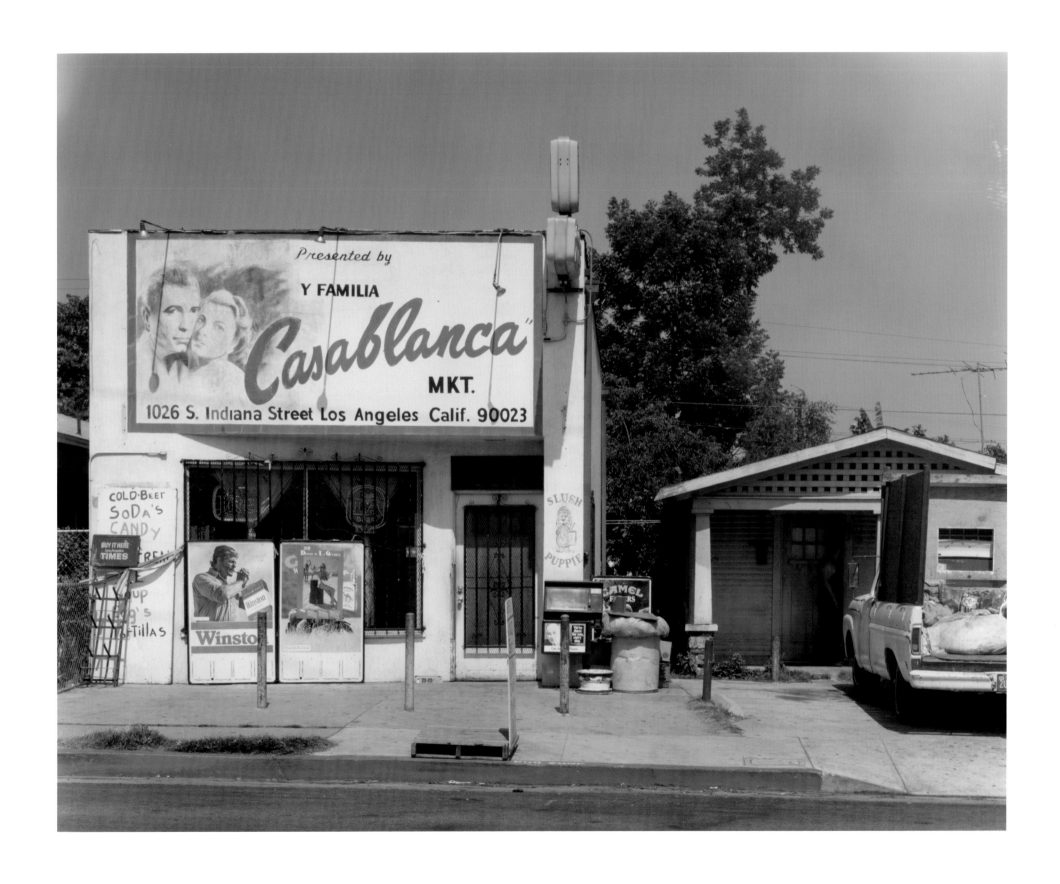

PLATE 11 *1026 South Indiana Street, East Los Angeles, June 26, 1986*

PLATE 12 *5519 East Gage Street, Bell Gardens, February 20, 1986*

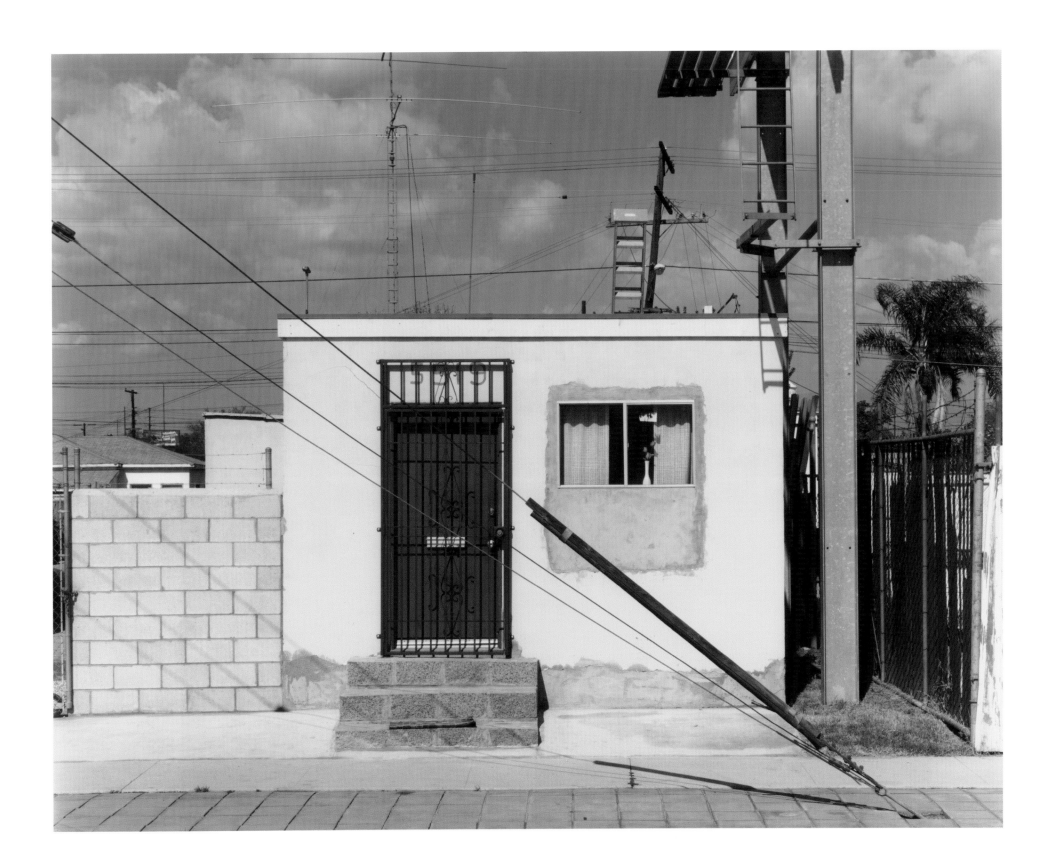

PLATE 14 *349 Rose Avenue, Venice, July 7, 1980*

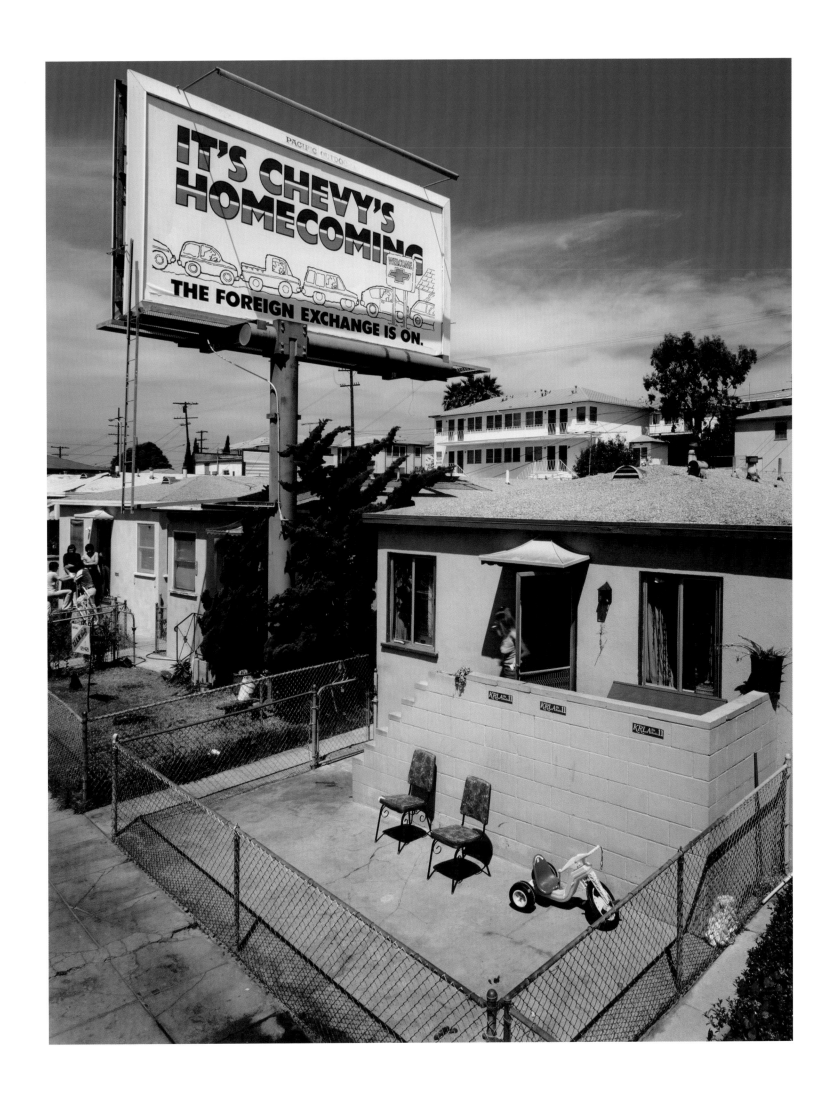

PLATE 15 *I-405 from 500 Block 33rd Street, Long Beach, June 4, 1980*

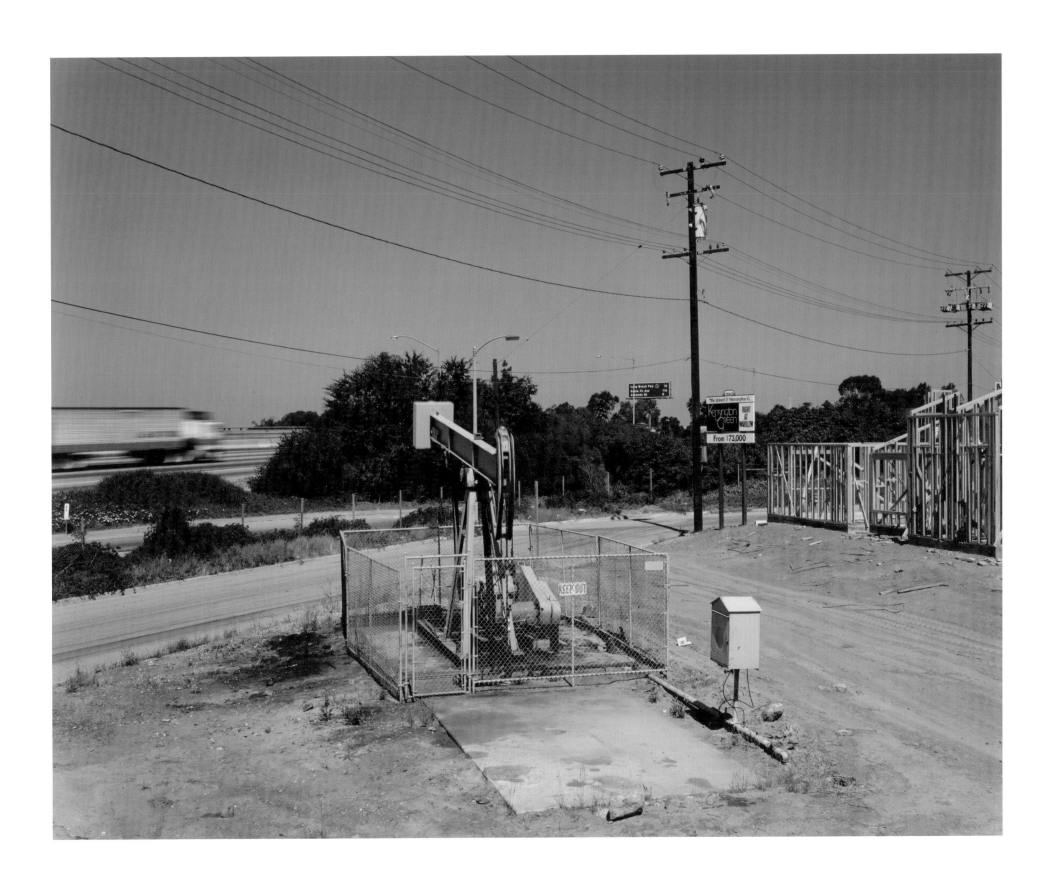

PLATE 16 *View West from 700 Block, Commercial Street, Los Angeles, April 12, 1987*

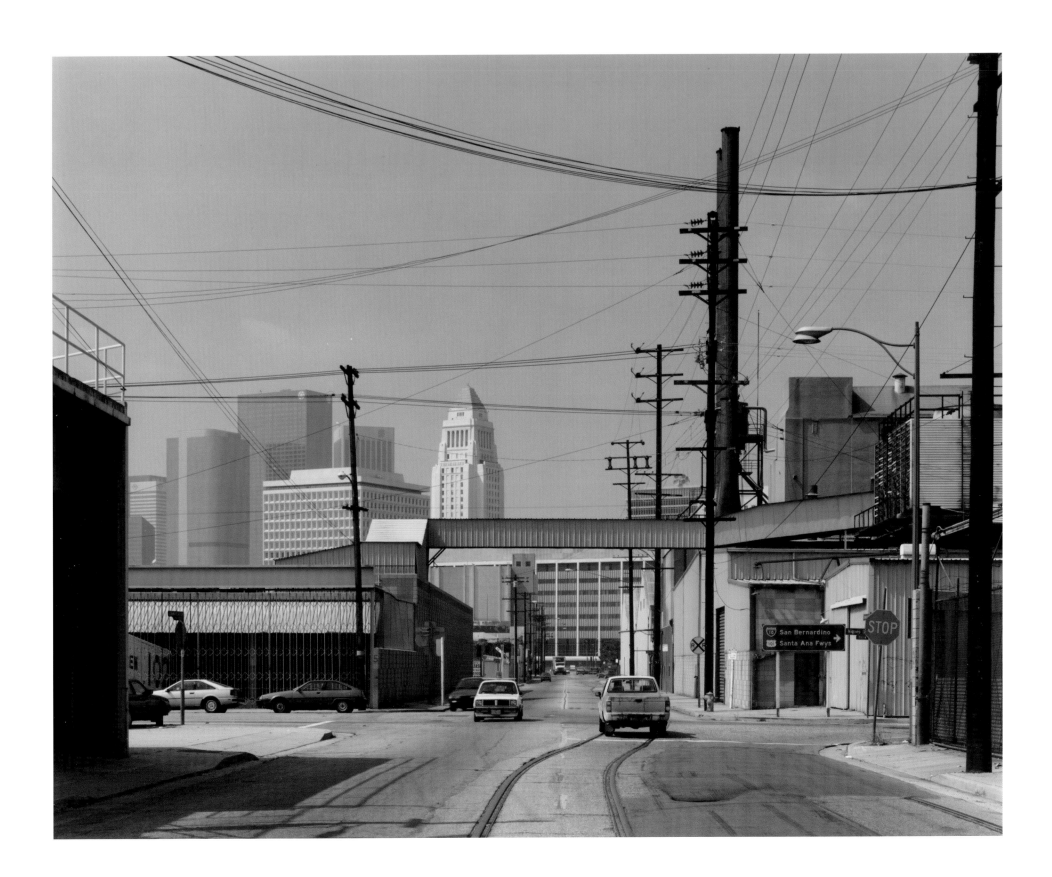

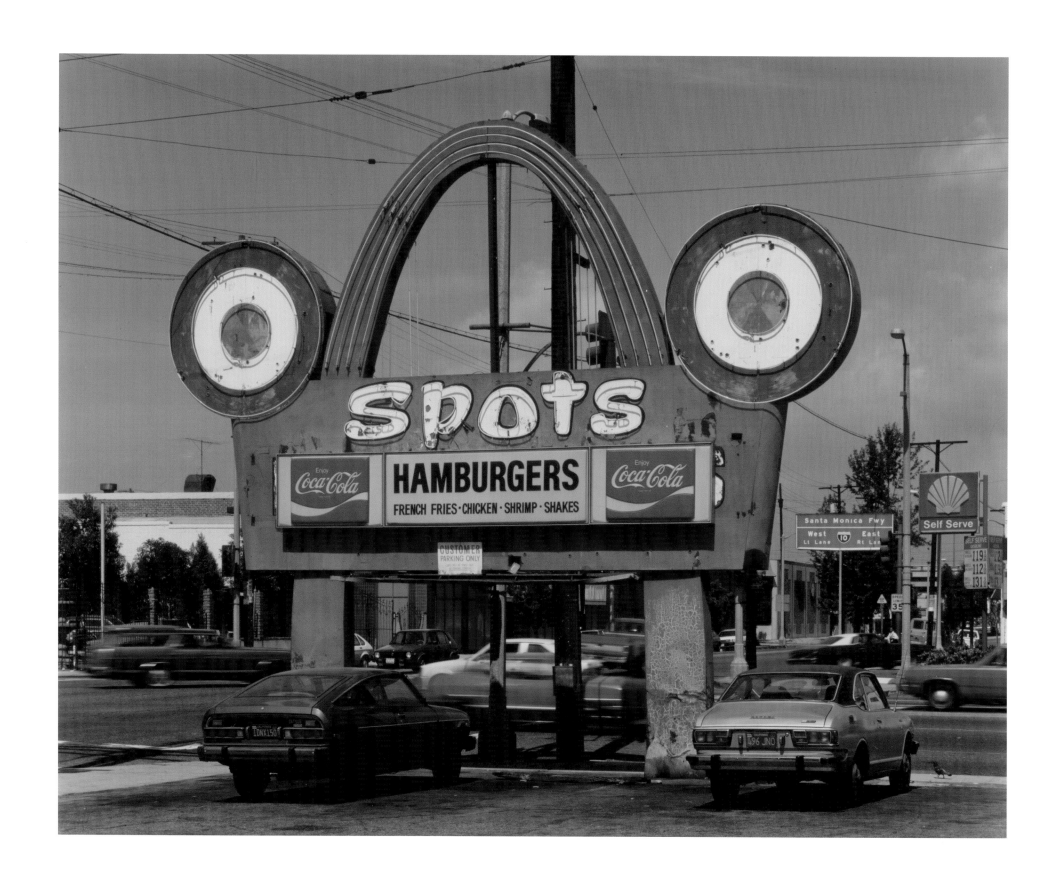

PLATE 17 *South Central and Washington Boulevard, Los Angeles, March 30, 1984*

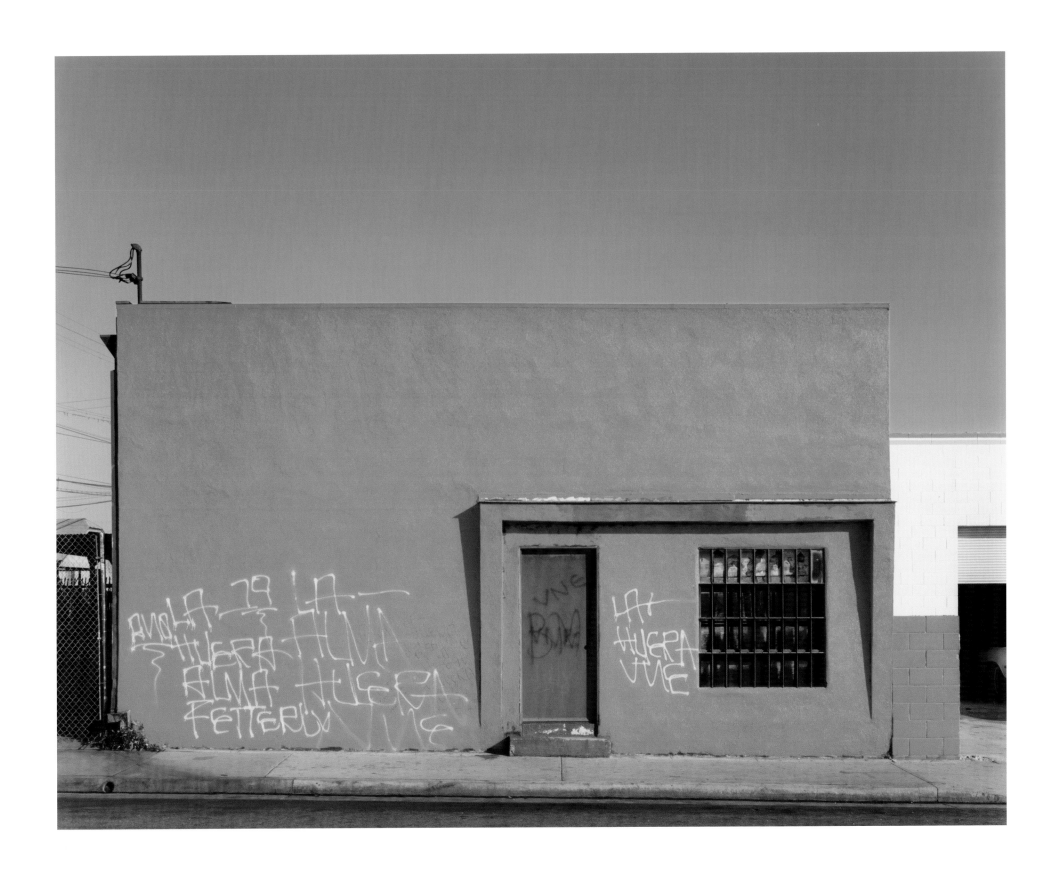

PLATE 18 *4801 East Olympic Boulevard, East Los Angeles, February 7, 1980*

PLATE 19 *Carson, November 13, 1979*

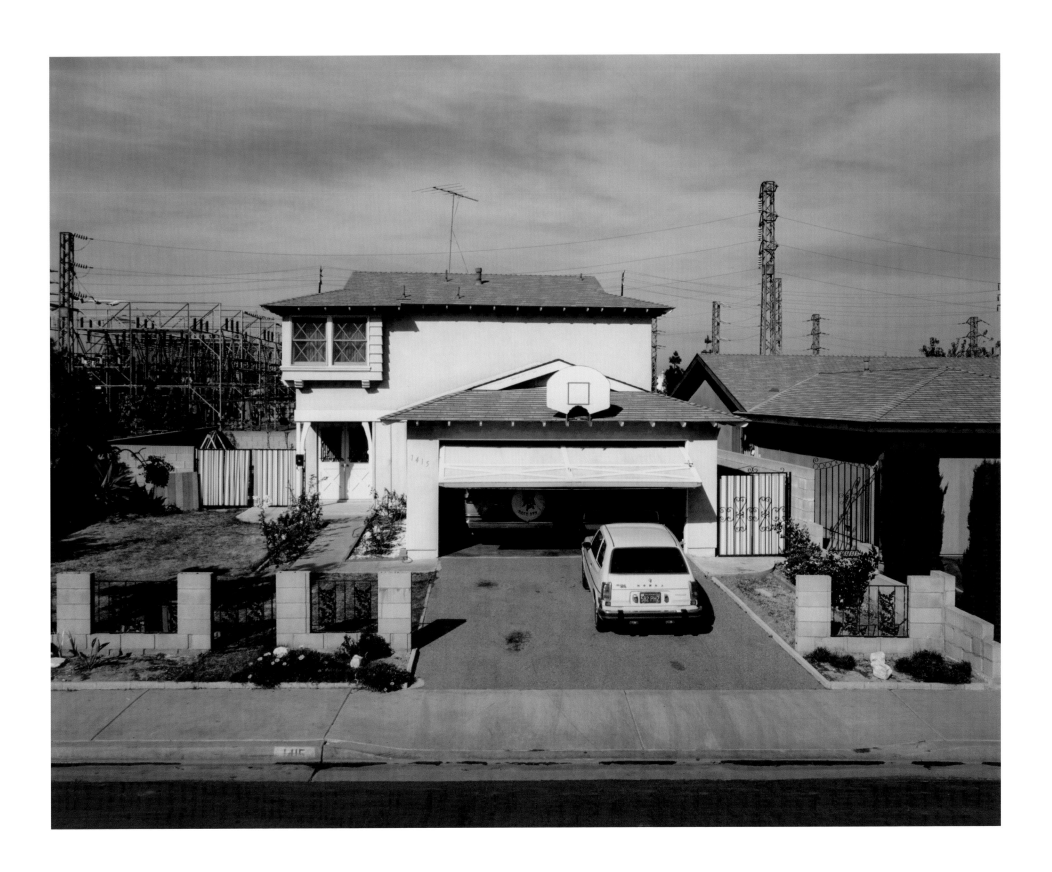

PLATE 20 *View North, I-105 at I-110, Los Angeles, January 15, 1991*

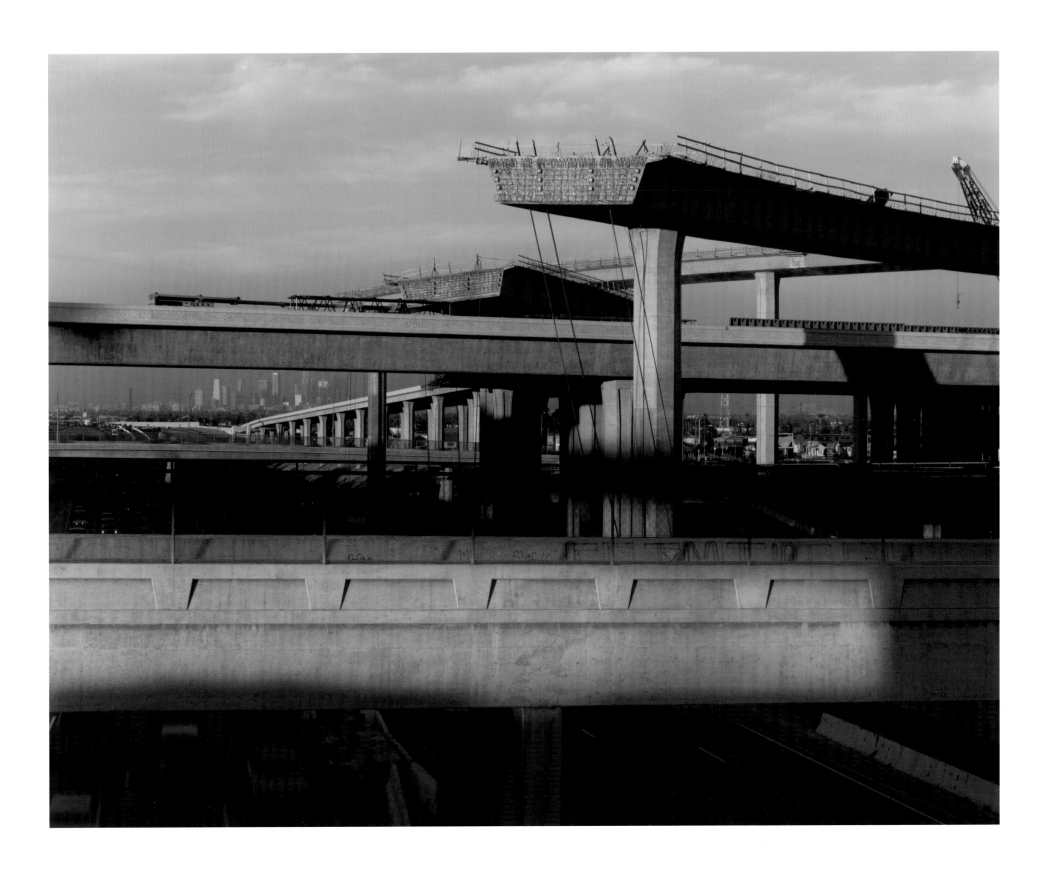

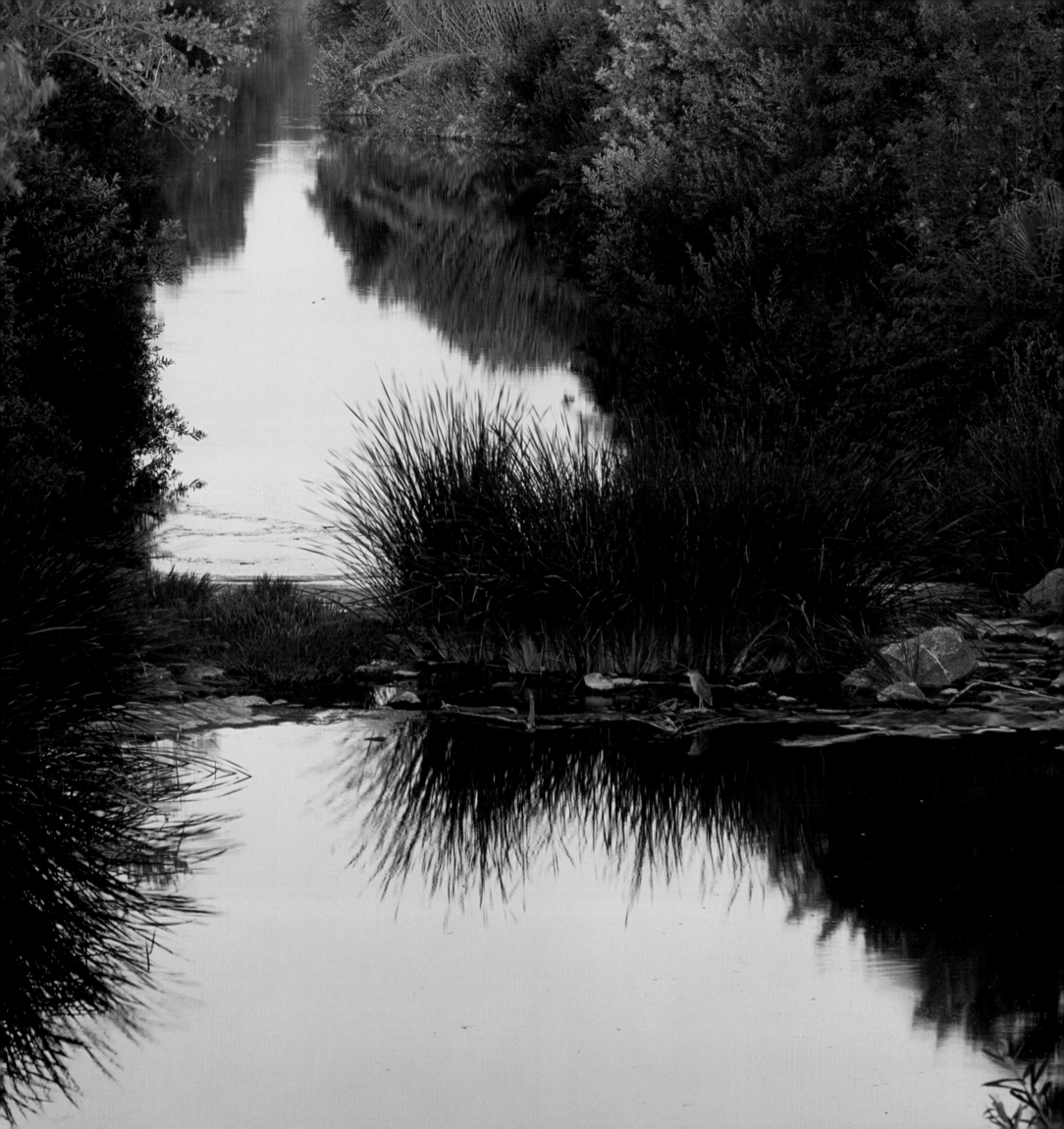

The Voice of the River

Gordon Baldwin

THE VOICE OF THE RIVER

 is a red wing blackbird
 twittering in the trash bags
 festooned across the
 branches of a cottonwood
 like prayer flags.

The freeways are louder than the River,
 The I-5, the 110, the L.B.
 overwhelm the River and its tributaries
 with their roar. But when the tributaries
 bring their gifts of rain water to the main stem

The River can be louder than
 the thunder rolling out of the San Gabriels.[1]

 Lewis MacAdams

In 1985, John Humble made his first photograph of the Los Angeles River; two more in 1996 and 1998. In 2001 he began a concerted series that, with its three antecedents, now numbers about sixty images. For the sake of geographical (and narrative) clarity, those that are reproduced in this book are arranged in a sequence starting at the river's source and moving downstream to the ocean. Because the river is the principal subject of all of these photographs, a capsule history of how it came to have its present appearance, which is so often unlike anything usually associated with the word "river," seems appropriate here.[2]

Even before human interventions, the Los Angeles River flowed only seasonally along much of its fifty-one-mile course, which—steadily augmented by minor streams—ran east from its subterranean source in Encino through the San Fernando Valley. At the east end of the Santa Monica Mountains it turned southeast and passed through the wooded Glendale Narrows, to arrive at a spot just south of its junction with the Arroyo Seco that would become the center of Los Angeles. From there the river moved south across the marshy coastal plain, frequently changing course, until it reached the Pacific near Long Beach. Because the river reliably and copiously flowed year-round only at the junction, and the adjacent land was very fertile, a neighborhood of Indian settlements grew up that were close to the riverbanks but raised above them, for the danger of flooding was perennial. In 1781, this area became the site of the pueblo of Los Angeles, established by the Spanish crown to produce food for the presidios (the military bases that secured Spain's hold on California) and for some of the missions in the string that ran northward from San Diego. This agricultural settlement grew steadily, and with it the need for water, which was distributed by an ever-expanding system of irrigation ditches that

Detail of *The Los Angeles River, Sepulveda Dam Recreation Area, 2001* (pl. 23).

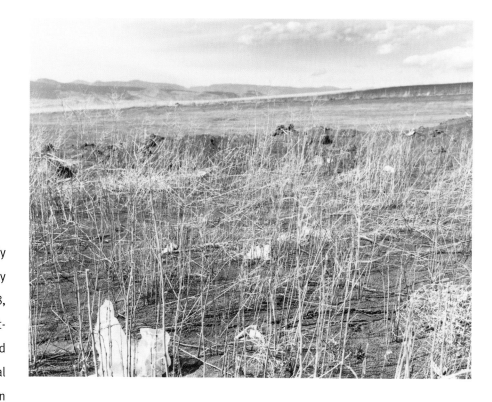

initially watered grain fields and vegetable gardens; from the early 1830s, vineyards; later still, fruit and nut trees and citrus groves. By the time California was ceded by Mexico to the United States in 1848, Los Angeles was firmly established as an important and highly profitable agricultural center, which it remained for fifty years. A household water-supply system was devised in the 1850s, but with the arrival of the transcontinental railways in 1876 and the resultant population explosion, previously unimaginable alterations to the town and river began to take place. The riverbanks downstream from the center of what had become a city were now lined with train yards and industry. The river's flow steadily diminished, so that by 1900, except during winter storms, its shallow bed south of the city became increasingly dry, barren, polluted, and trash-laden: as Humble has written, the river was being "exploited to extinction."[3] Endemic flooding caused extensive property damage, including the washing away in the 1860s of most of the vineyards. This led to ineffective efforts to channel the riverbed. In the 1880s, further flooding led to further unavailing efforts, mainly levee building. Growing urbanization meant more barriers to natural water flow, less land to absorb rainfall, and more impermeable surfaces, which increased rapid runoff. A major inundation in 1914 led to the beginnings of an extensive coordinated regional system of river controls. Federal government interventions followed, and in 1938 a calamitous flood led to the decision effectively to encase the whole length of a straightened, deepened riverbed in a concrete channel. Over thirty years the Army Corps of Engineers accomplished this, and the river as it is today, with concrete banks along ninety-four percent of its course, is the result. The principal year-round source of its flow is now the considerable discharge released from two sewage treatment plants. Into this environment John Humble first ventured in 1985.

The spot where the river begins is now considered to be at the point in the San Fernando Valley, in Canoga Park, where Bell Creek, which has just been augmented by Chatsworth Creek, meets Arroyo Calabasas (pl. 21).[4] In Humble's dramatic upstream view, four great arcs of water, concrete, and sky thrust forward to terminate in a slender cylinder that cleaves the picture vertically into sun and shadow like the prow of a ship parting waves. The image is also roughly symmetrical horizontally, resulting in an exceptionally strong composition. As even at its source the river is walled, to make his picture Humble had to walk three hundred yards downstream before he found a place at which he could step into the riverbed. Rubber-booted, he gingerly walked back upstream to set up his tripod in the water and photograph this 1958 construction.

Although at first glance the view of the river in Reseda may seem to show a relatively pristine environment, a second look shows a light dusting of bits of paper, plastic bags, and miscellaneous debris, as well as a snippet of fence at the left and a single stadium light pole at the right (pl. 22). This detritus apparently was carried into place by runoff during the previous winter. As the range of colors here is narrow and the abundant foliage evenly diffracts light, this photograph has a more homogenous overall surface texture than most in the

series. Although in color rather than black and white, it is somewhat reminiscent of the work of Robert Adams, whose work is overtly concerned with environmental issues (opposite page).

The most wholly pastoral of Humble's images of the river is his sundown view made in the large park associated with the Sepulveda Dam (pl. 23). Here, a substantial amount of treated wastewater, up to seventy-five million gallons a day, is released into the river. Although not apparent in the photograph, some of the sides of this stretch of the river are lined in concrete, but the bottom is not,[5] and for this reason the waterside growth is more abundant. The photograph, which seems suffused with autumnal light, is probably the most overtly romantic of all of Humble's works. Emblematic of the apparent serenity is the bird perched on a stone in the center foreground (p. 50). Beyond it, through the progressively narrowing channel, the eye is led into the depths of a landscape that terminates in the violet hilltop in the distance.

The view of the Sepulveda basin park in golden light was made from a bridge across the river that Humble photographed while the light still lasted (pl. 24). At other times of day the color of the bridge supports would have been a dull utilitarian grey, but the light at sunset gilded their edges and surfaces, transforming the scene into a grand architectonic stage set.[6] The massive columns reflected in the water resemble the interior of a vast Roman subterranean cistern, like those at Pozzuoli, near Naples, and at Istanbul, but with better overall lighting.

Studies of a variety of spans across the river punctuate this series, ranging from the sun-gilded Atlantic Boulevard bridge at Vernon, seen on the diagonal (pl. 33), to the gloomy, rain-drenched freeway, the I-105, which Humble photographed with a hand-held camera from a car window of a vehicle on another tentacle of the same highway (pl. 39). Because the latter picture was made in a downpour during the 1997–98 El Niño,[7] there was so much water that a double strand plummeted off the topmost span, and down below a great volume of water ominously eddied along the embankments that contained it. Despite the fact that the sky lightens slightly to the west, perhaps this can be taken to be Humble's emotionally darkest image, his most Chandleresque. Still another way that Humble has used the bridges is as framing devices for riparian views (pls. 25, 34).

The Glendale Narrows are an eight-mile stretch that provides the San Fernando Valley and the Los Angeles River with their sole outlet to the Los Angeles Basin and the Pacific Ocean. Through this slender north-south passage squeeze the I-5 freeway, two important surface streets, the railroad tracks of two different lines, the river itself, and a relatively new bicycle path. The river's flow here is particularly strong, partly due to the pressure of upwelling groundwater compressed between the end of the granitic Santa Monica Mountains to the west and the Verdugo Mountains to the east. The water table is so high that paving the river bottom with concrete was impossible, which accounts for the more natural appearance of the riverbanks: for the willows, sycamores, and cattails along the edges, and for a high population of aquatic birds. Humble's principal study of this narrow stretch of water (pl. 26) was made in winter from the western side, which he reached by using the sole footbridge that crosses the river. The emphatic horizontality of the five bands that traverse his composition—sky, hills screened through trees, the embankment with trees and undergrowth, water, and foreground sandy sediment—is tempered by the diagonal slanting shadows of the shoreline trees. Masses of riverine

1. Lewis MacAdams, *The River: Books One, Two & Three* (Santa Cruz, 2005). Used with permission of the author.

2. The radically abbreviated summary of the history of the river that follows is nearly entirely drawn from Blake Gumprecht's authoritative *The Los Angeles River: Its Life, Death, and Possible Rebirth* (Baltimore, 1999 and 2001).

3. "Fifty One Miles of Concrete," artist's statement distributed by the Jan Kesner Gallery, Los Angeles, in conjunction with an exhibition of the same name in 2002, p. 1.

4. The river's longtime lack of cultural importance is indicated by the fact that in the *Thomas Guide*, the driver's bible of Los Angeles, its admittedly thin, upstream reaches are marked as a nearly invisible dotted line. See the maps in the *Los Angeles County 1990 Thomas Guide* (Los Angeles, 1989), 14, 15, 22, 23.

5. These characteristics of the channel are noted in Joe Linton's highly informative *Down by the Los Angeles River: Friends of the Los Angeles River's Official Guide* (Berkeley, 2005), 34. An online tour of the river, although now somewhat dated, can be found at *www.urbanedpartnership.org/target/units. river/tour.*

6. Suitable, perhaps, for act 1, scene 2 of Verdi's *Aida*.

7. Roughly defined, El Niño is a sustained sea-surface temperature anomaly, an abnormal warming of northerly currents in the central tropical Pacific Ocean that has the effect in California of increased storm activity and winter rainfall. The El Niño of 1997–98 was particularly strong. See *http://en.wikipedia.org/ wiki.El_Ni%C3%B1O.*

8. Founded in 1986 by Lewis MacAdams, the Friends have proved to be effective advocates for a humanistic approach to the river, reclaiming it for recreational use and for its beautification. The movement to reclaim the river is growing: North East Trees—one of several allies of the Friends—is responsible for the establishment of a series of pocket parks in the midsection of the river near the Glendale Narrows.

9. The photographer has described the channel south of Los Angeles as being of surreal proportions. See "Fifty One Miles of Concrete" (note 3). Despite its breadth, up to 170 yards in places, after heavy rainfall floodwater sometimes moves through this section of the channel at nearly forty miles an hour.

10. This view of the river, from Soto and Bandini streets in Vernon, was made fifteen years earlier than the others under discussion here and does not fully share their characteristics, as train tracks and a telephone pole are too prominent. By employing the technique of burning in, Humble darkened the foreground and some areas of the sky.

11. This 1996 image with its mid-river debris anticipates somewhat similar work made at a slightly later period by Anthony Hernandez (American, b. 1947) in and around the river. See M. G. Lord, *Anthony Hernandez: Everything* (Tucson, 2005). Some of the river imagery of both photographers, along with that of Lane Barden, and the artists Helen Mayer Harrison and Newton Harrison, Dana Plays, and Gary Schwartz, appeared in an exhibition *L.A. River Reborn* at the Skirball Cultural Center in Los Angeles, April 6–September 3, 2006.

12. The dome was built for the display of Howard Hughes's giant flying boat, the *Spruce Goose*, which was built of laminated wood during World War II, with ten propellers and the largest wingspan of any aircraft in existence. It was moved elsewhere in 1992, and the building now serves as the terminal for a cruise line.

Detail of *The Mouth of the Los Angeles River, Long Beach, 2001* (pl. 40).

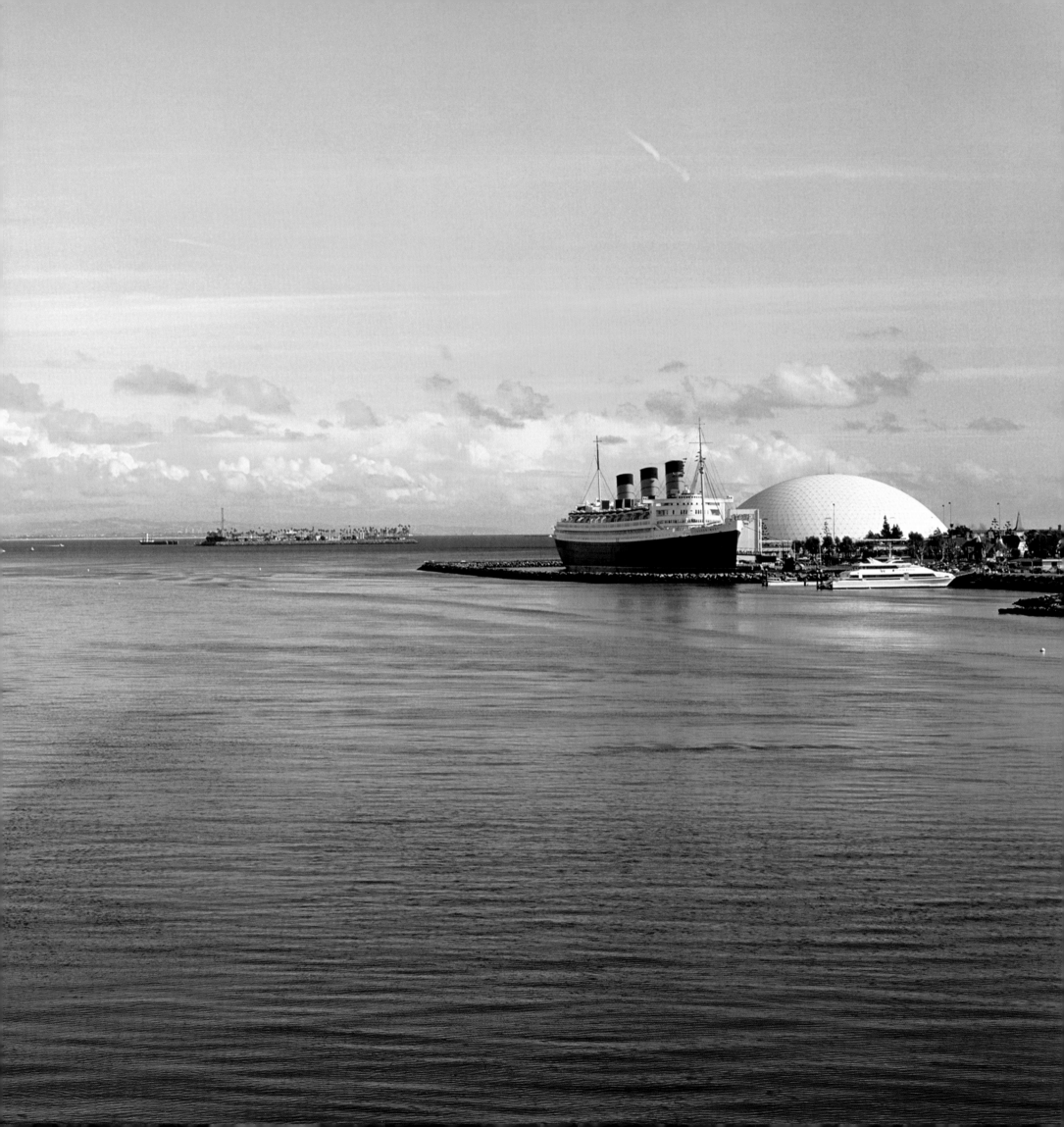

PLATE 21 *Headwaters, The Los Angeles River, Confluence of Arroyo Calabasas and Bell Creek, Canoga Park, 2001*

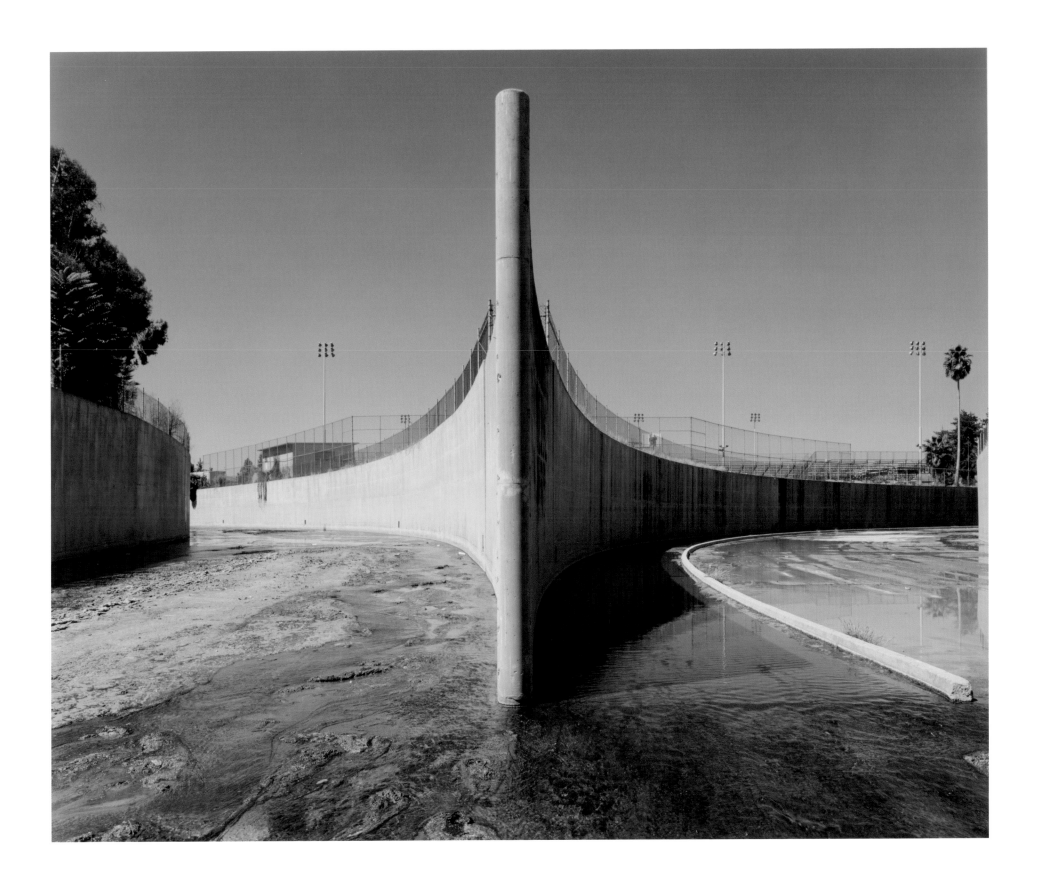

PLATE 2 2 *The Los Angeles River near Victory Boulevard, Reseda, 2001*

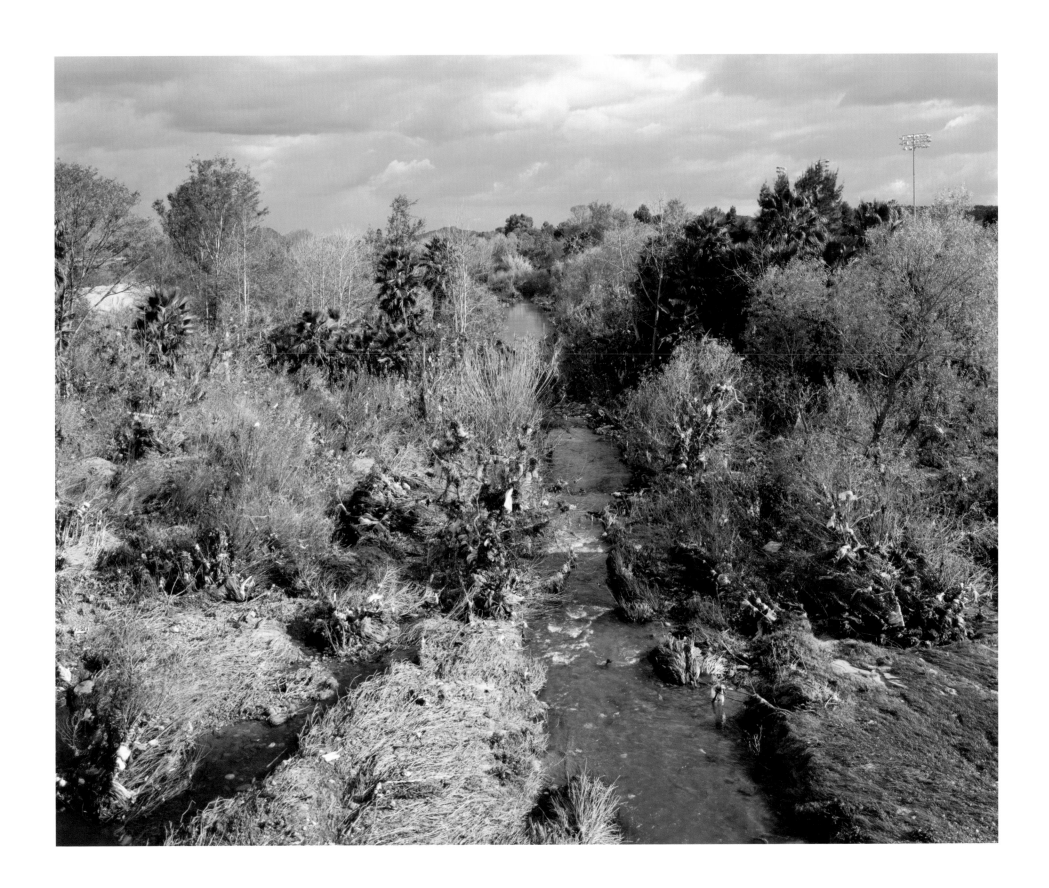

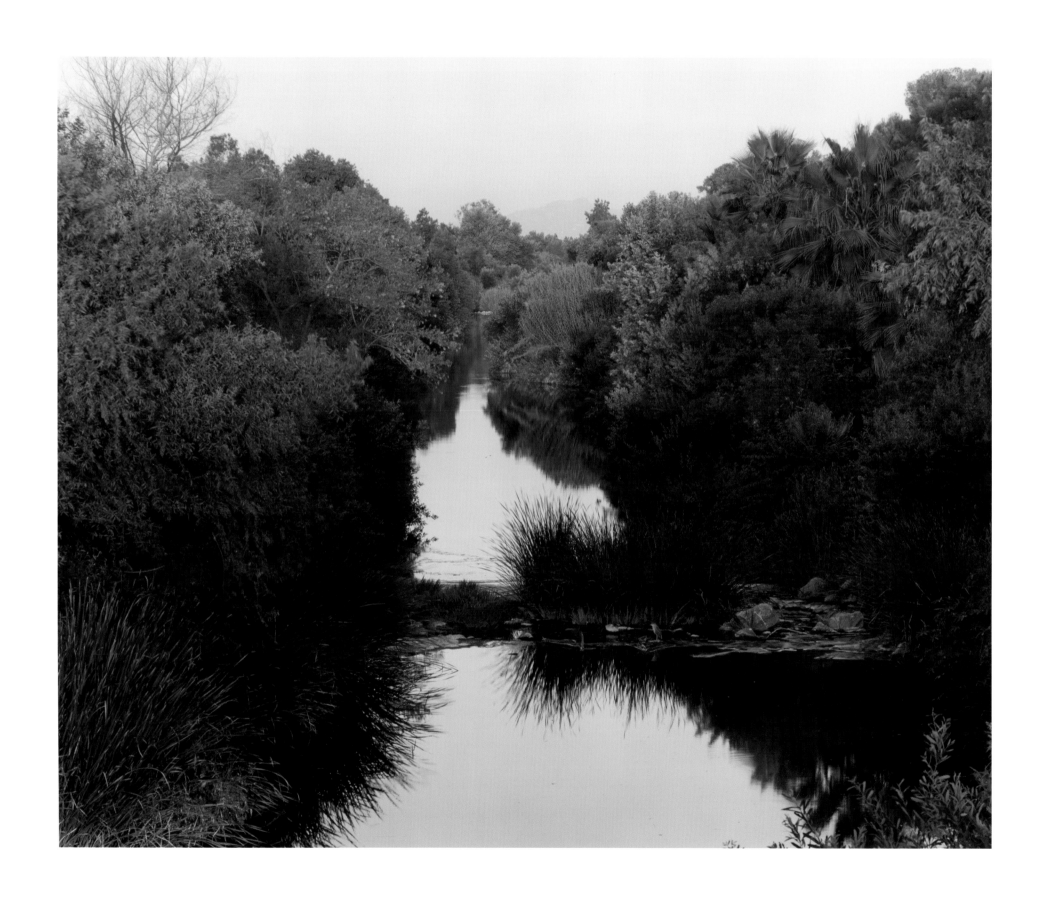

PLATE 23 *The Los Angeles River, Sepulveda Dam Recreation Area, 2001*

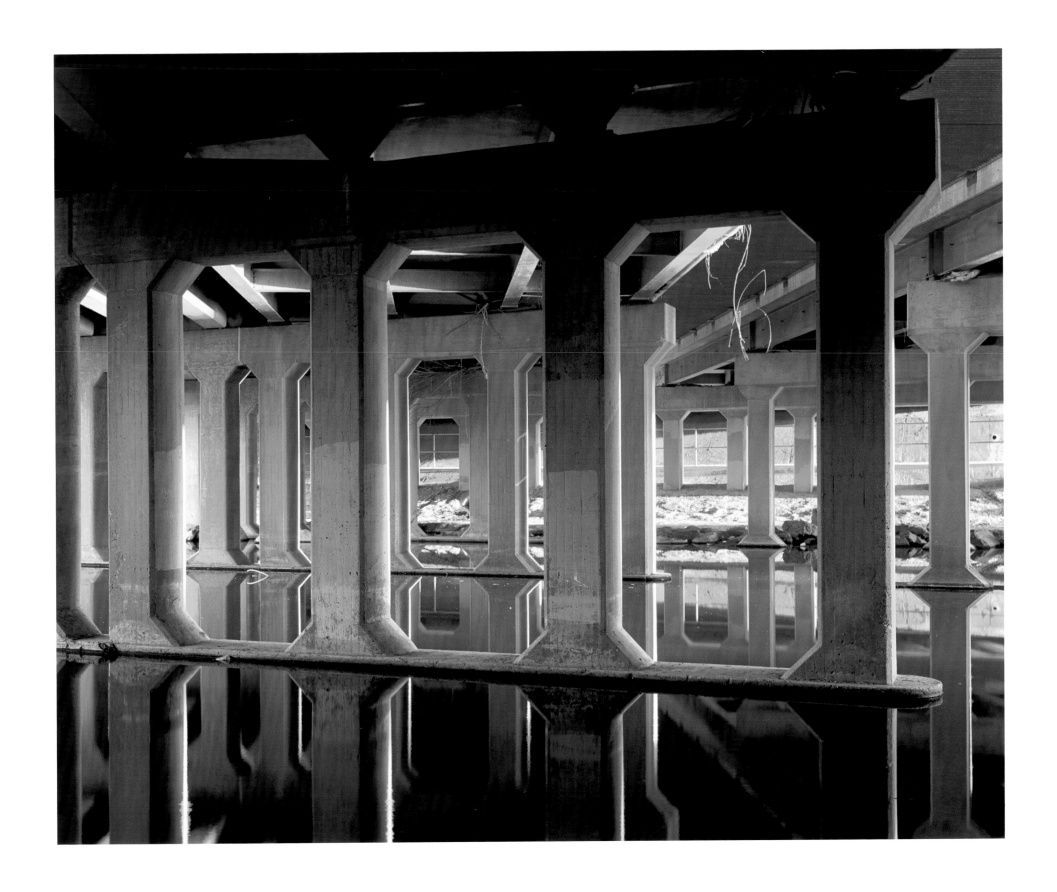

PLATE 24 *The Los Angeles River, Balboa Boulevard Bridge, Encino, 2001*

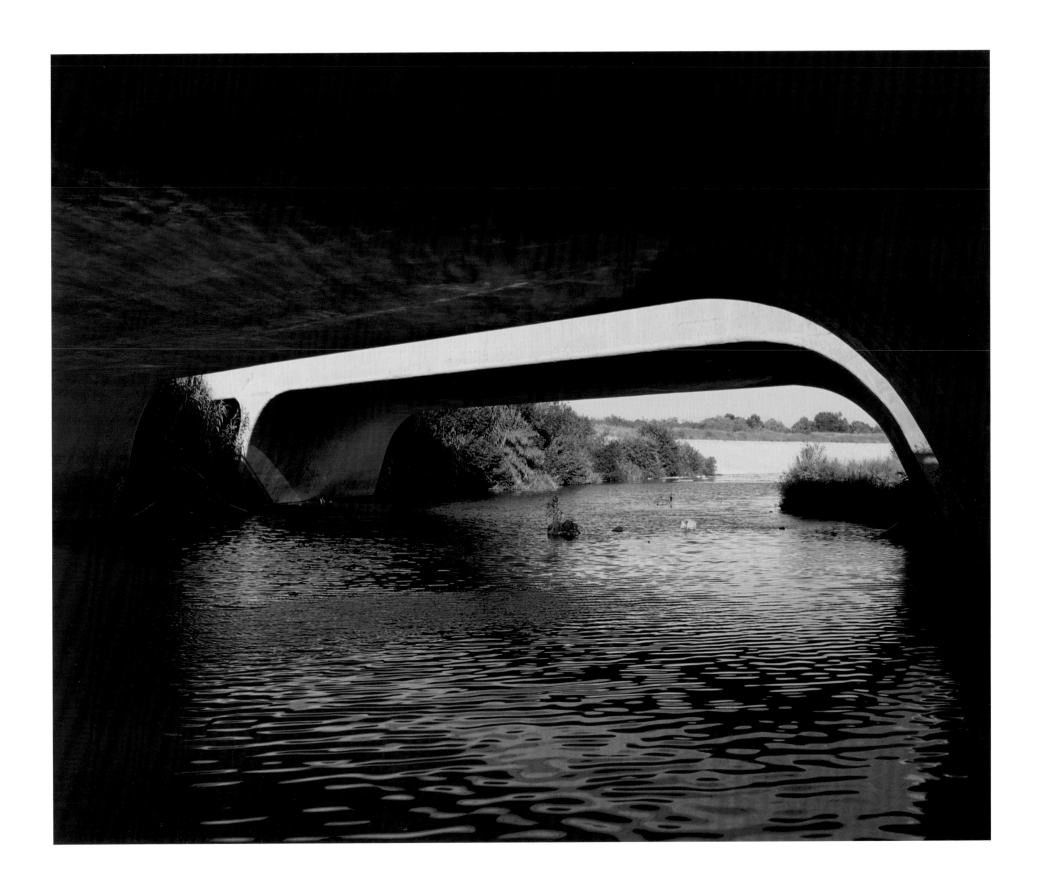

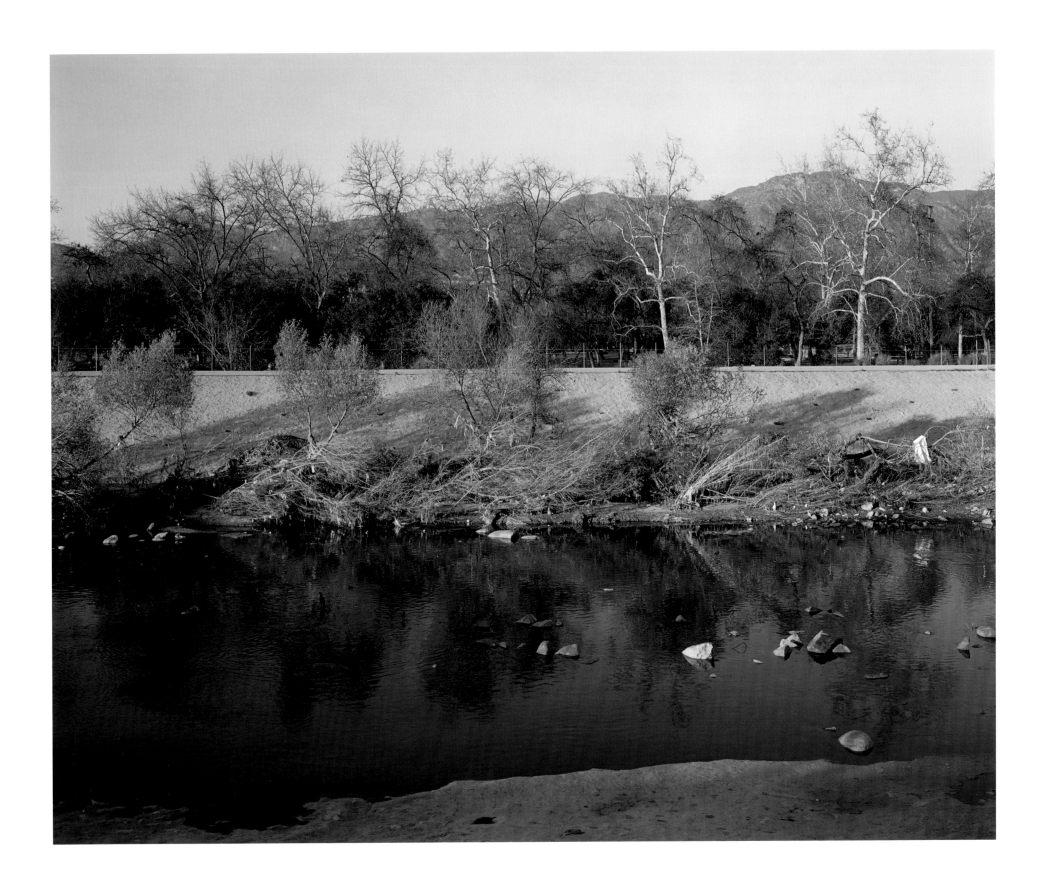

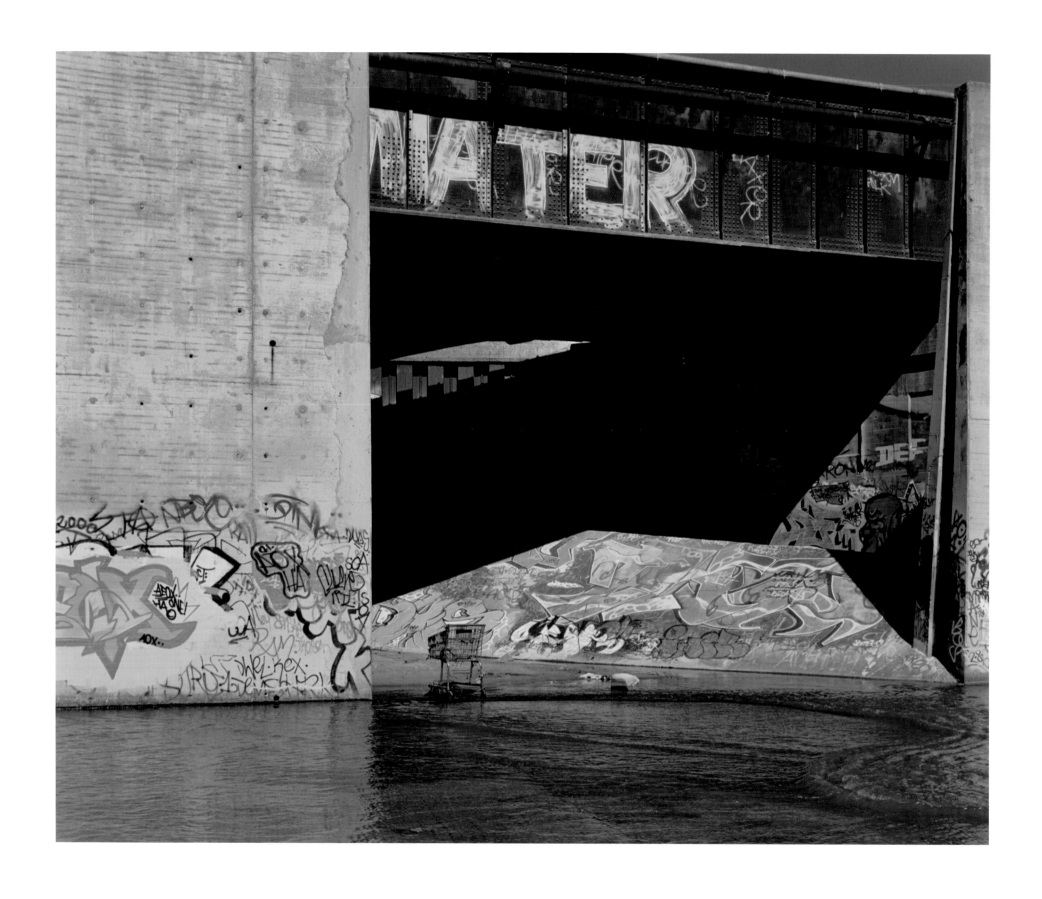

PLATE 27 *The Los Angeles River just above the Arroyo Seco, Los Angeles, 2001*

PLATE 28 *The Los Angeles River from Main Street, Los Angeles, 2001*

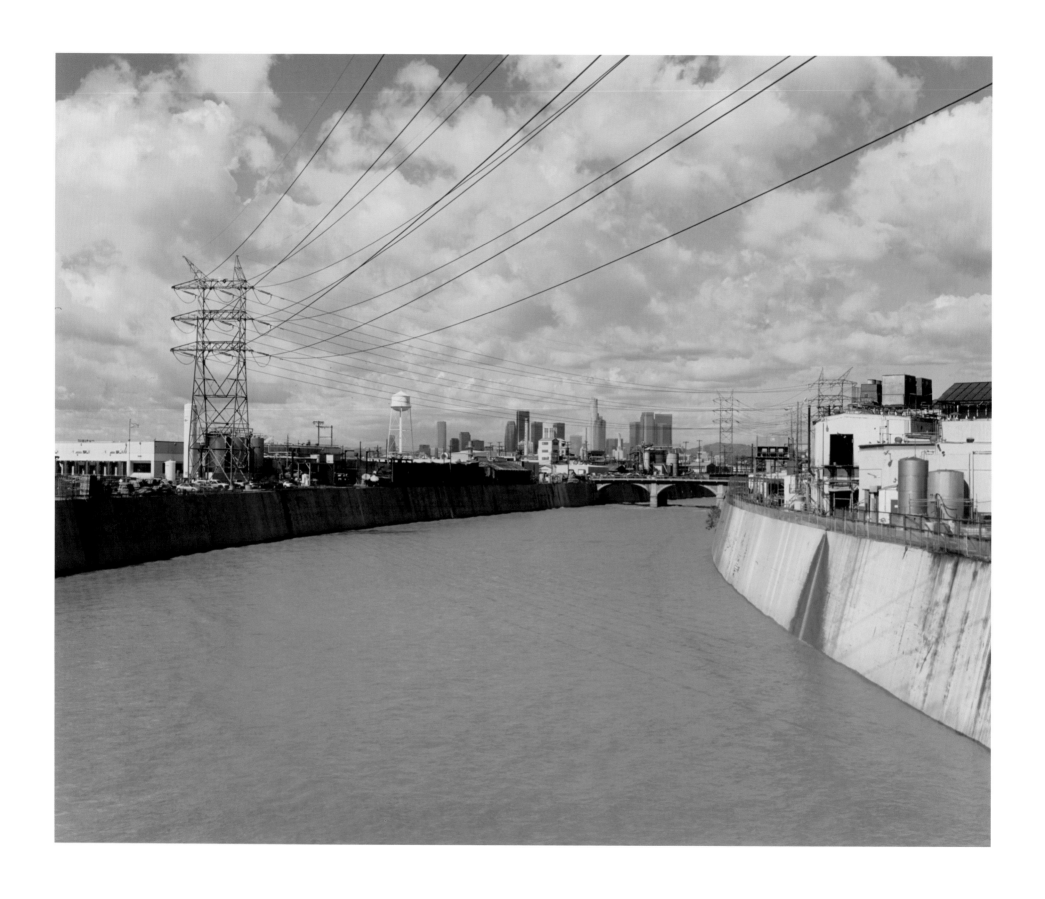

PLATE 29 *The Los Angeles River from Soto Street, Vernon, 2001*

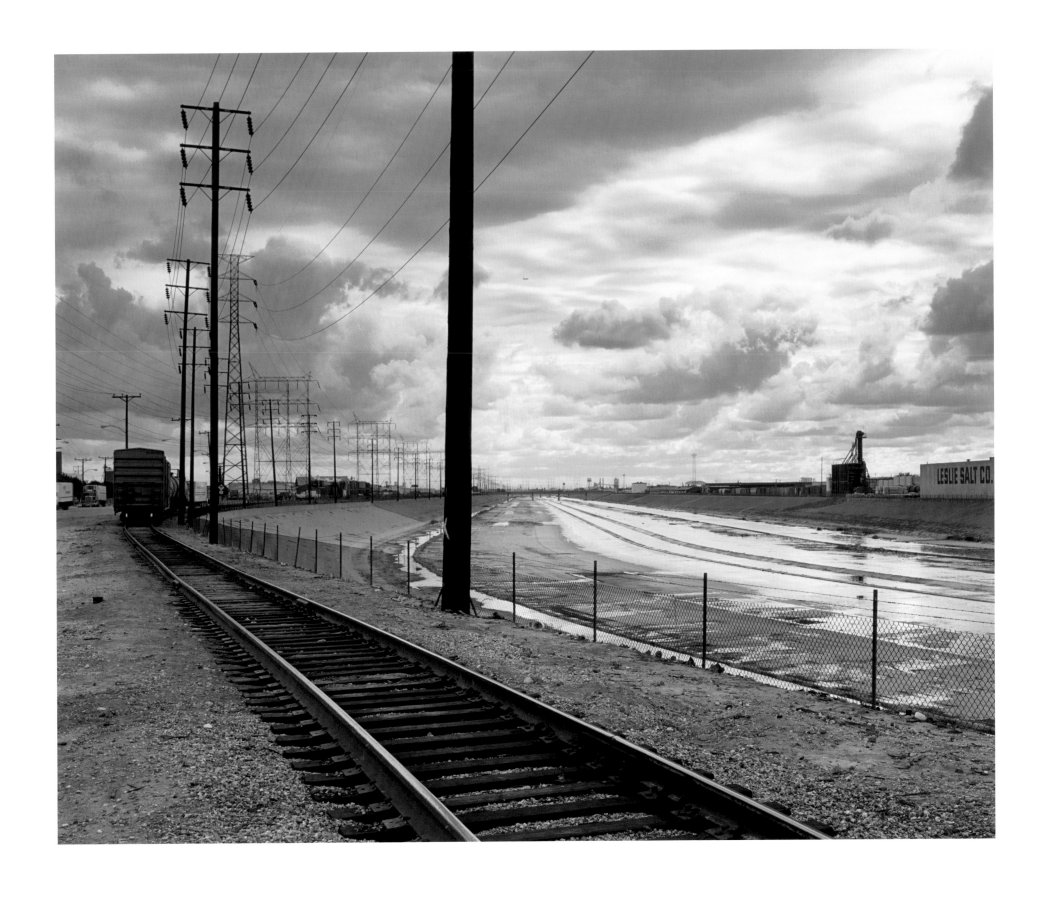

PLATE 30 *The Los Angeles River from Soto and Bandini, Vernon, 1985*

PLATE 31 *The Los Angeles River from Downey Road, Vernon, 2001*

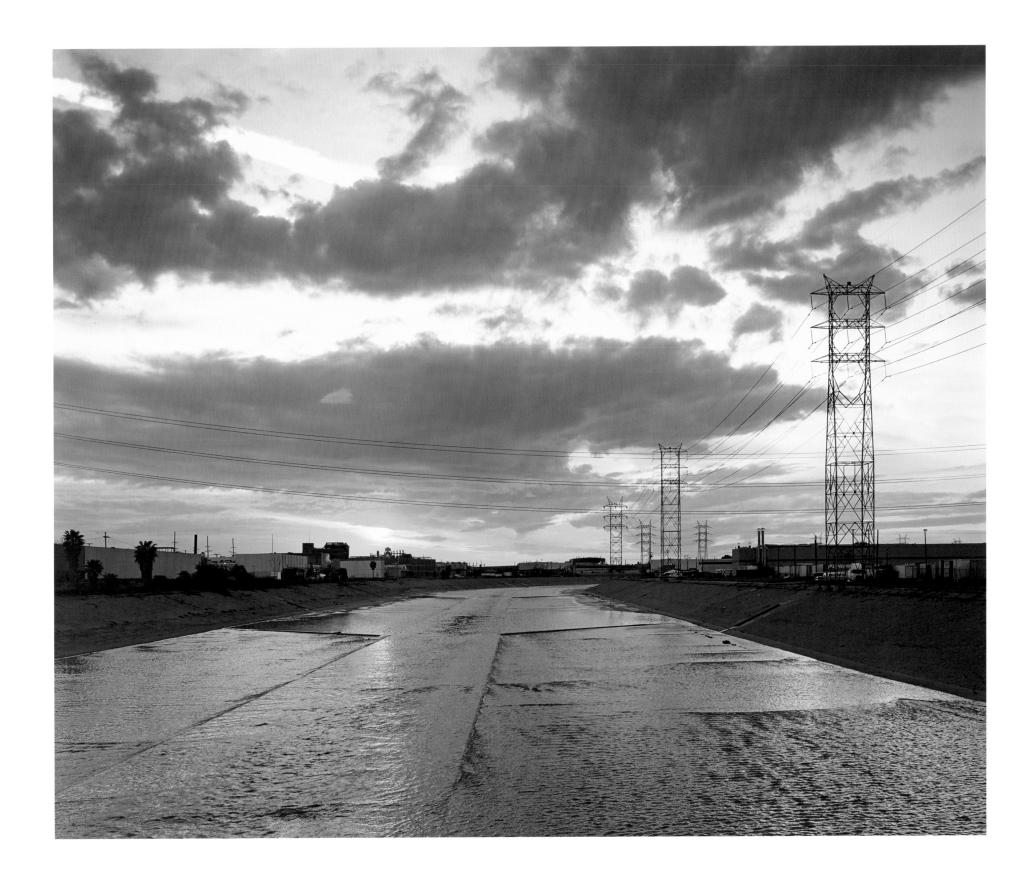

PLATE 3 2 *The Los Angeles River near Downey Road, Vernon, 2002*

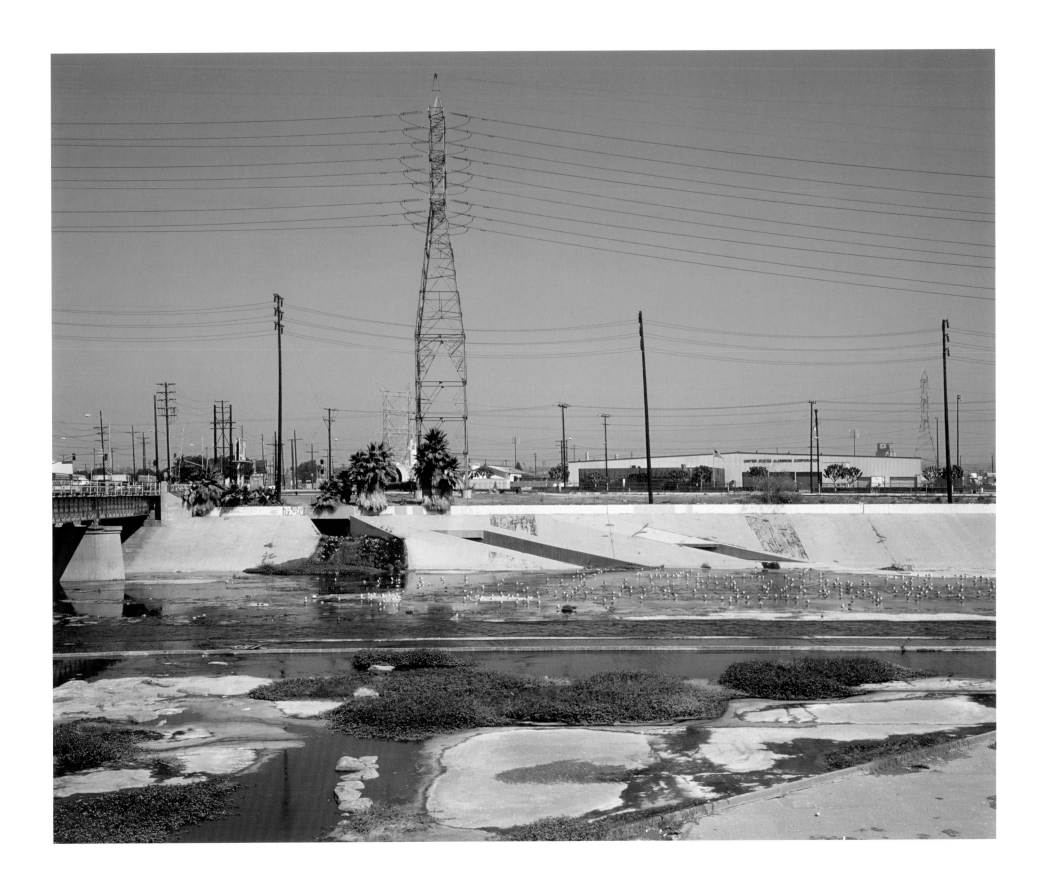

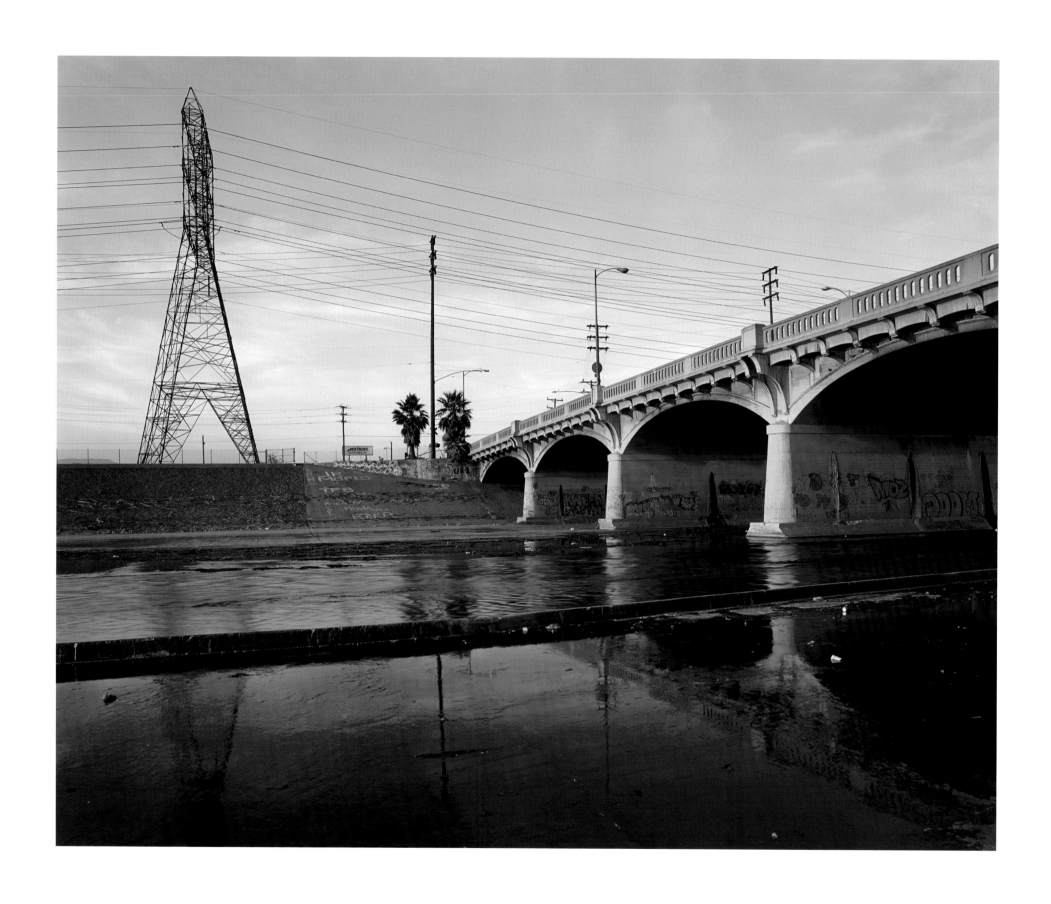

PLATE 3 3 *The Los Angeles River at Atlantic Boulevard, Vernon, 2001*

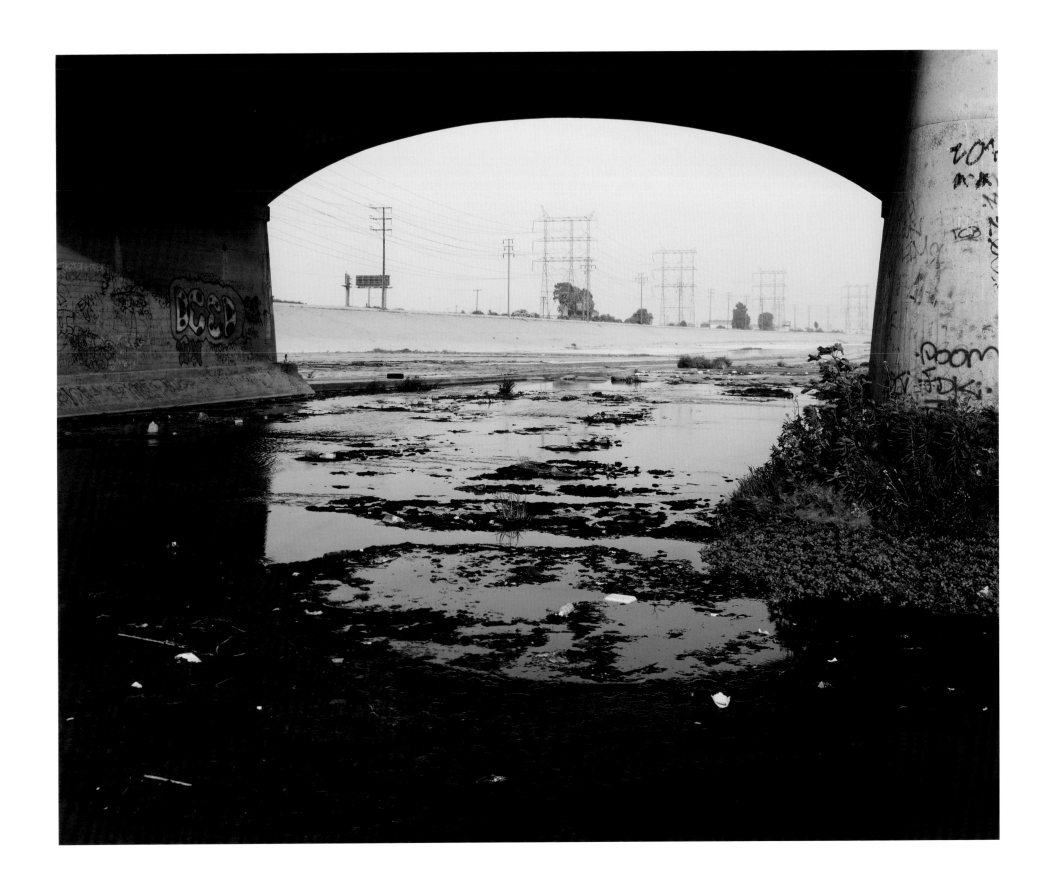

PLATE 34 *The Los Angeles River near District Boulevard, Vernon, 1996*

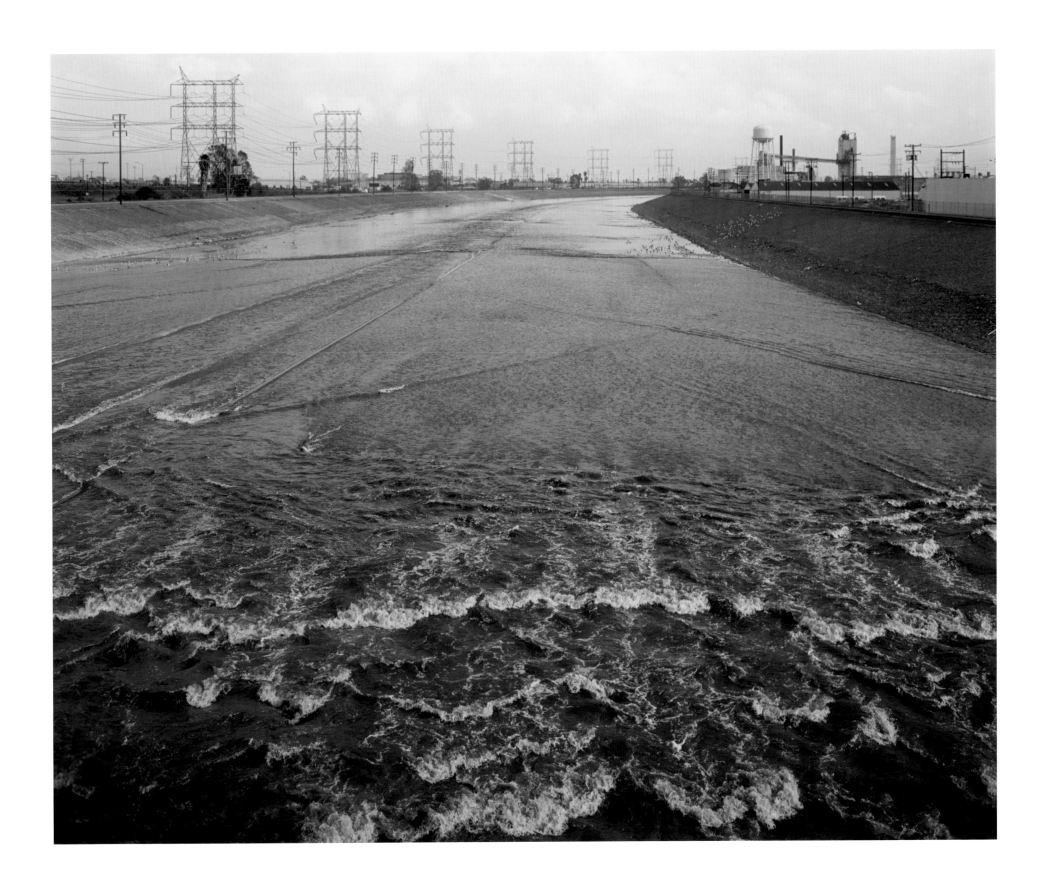

PLATE 36 *The Los Angeles River from Gage Avenue, Bell, 2001*

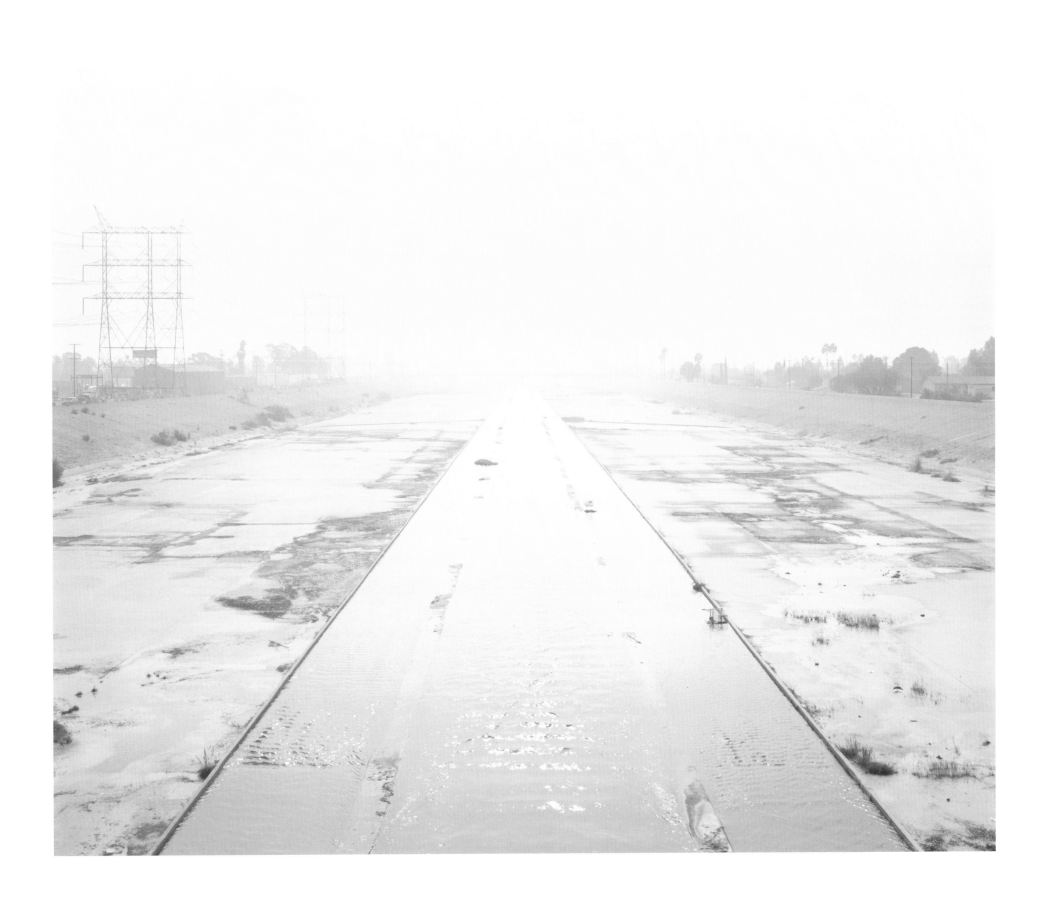

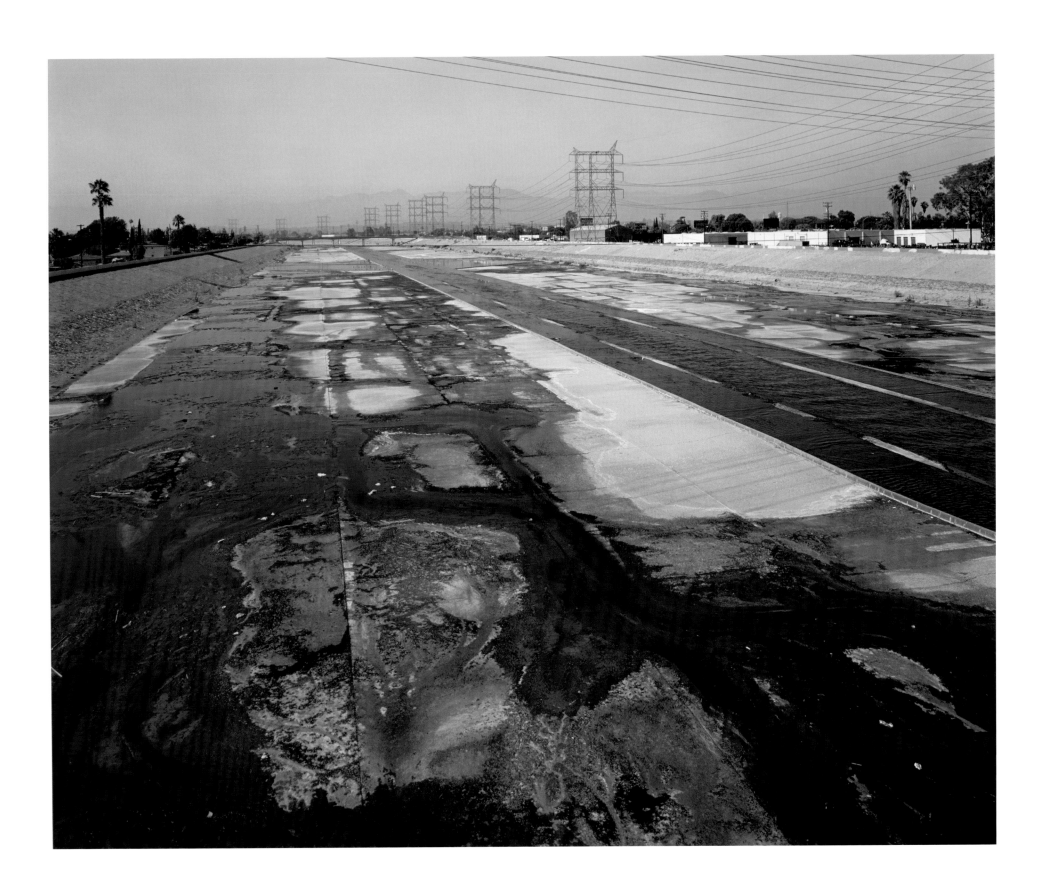

PLATE 3 8 *The Los Angeles River from Florence Avenue, Bell, 2001*

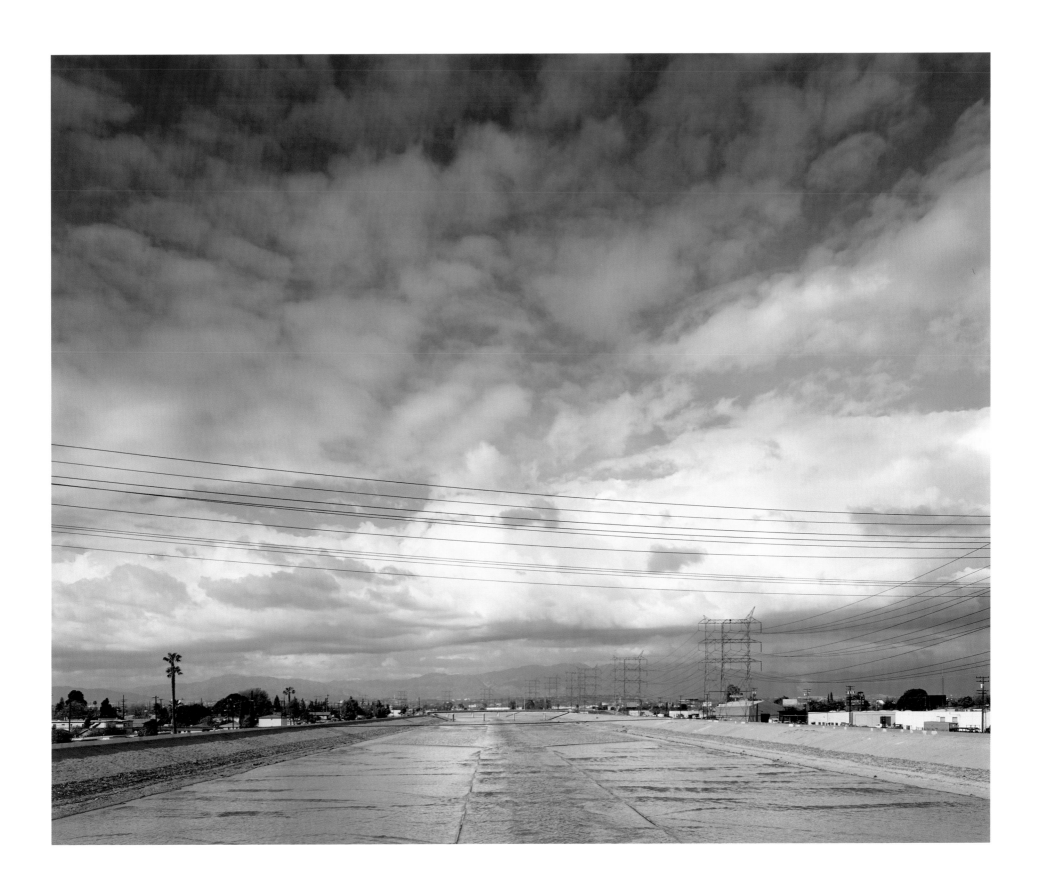

PLATE 39 *The Los Angeles River from the I-105, Paramount, 1998*

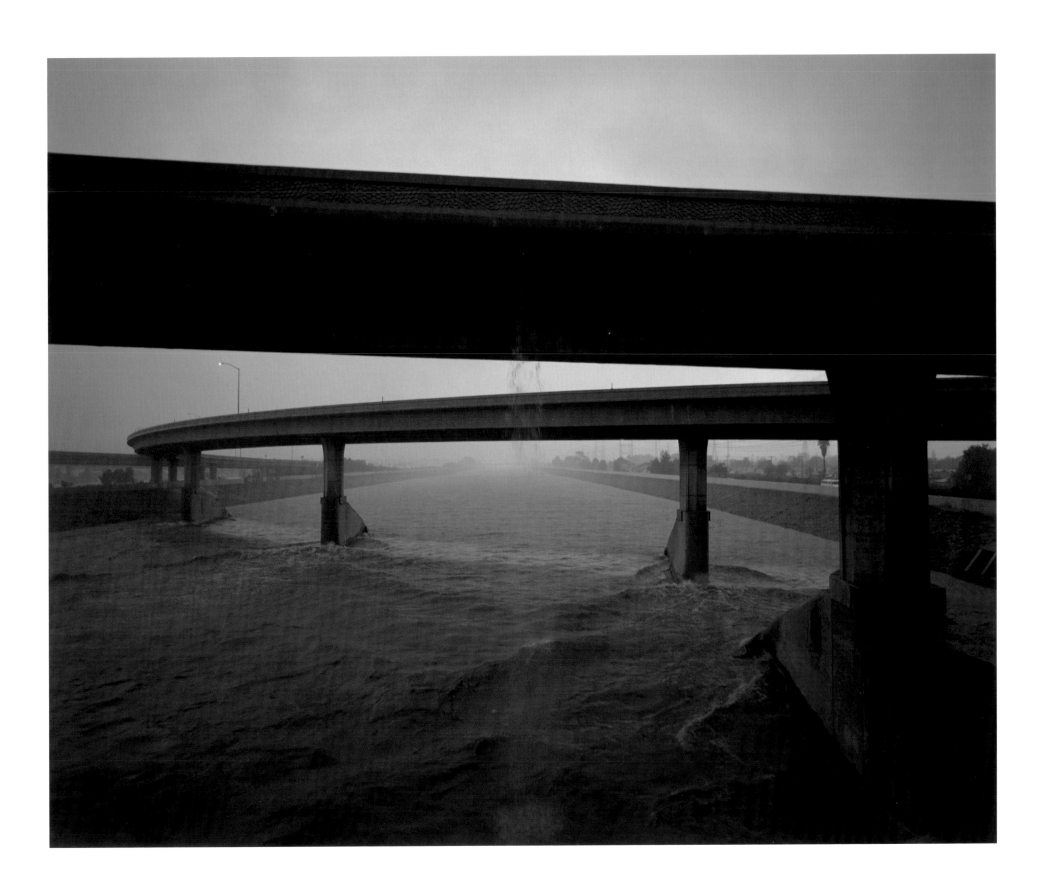

PLATE 4 0 *The Mouth of the Los Angeles River, Long Beach, 2001*

88 | 89

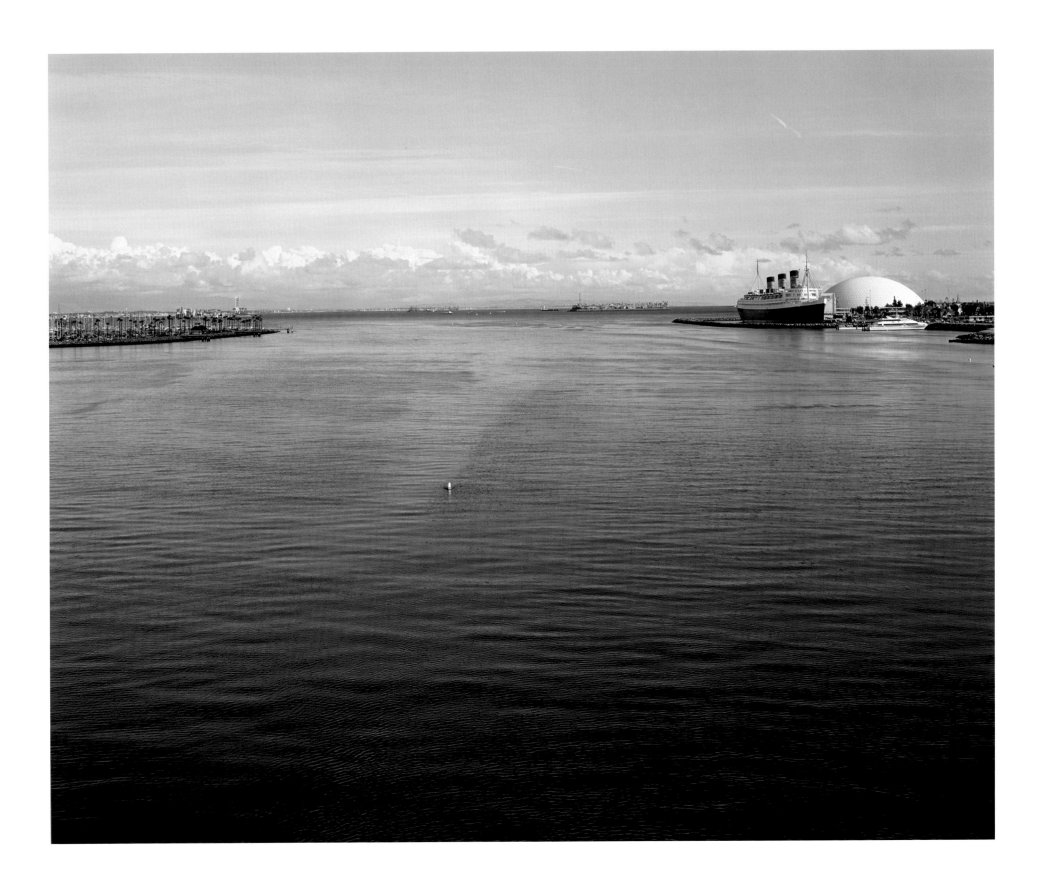

Checklist

Unless otherwise specified, prints were made in the year included in the title and are in the collection of the J. Paul Getty Museum.

PLATE

1 *View South from Recreation Road, Carson, May 2, 1980*
Chromogenic print
40.6 × 50.8 cm (16 × 20 in.)
T.2006.59.5

2 *178th Street at Manhattan Place, Torrance, September 20, 1979*
Chromogenic print
50.8 x 40.6 cm (20 x 16 in.)
T.2006.59.3

3 *View West from 100 Block Myers Street, Los Angeles, June 17, 1992*
Chromogenic print
40.6 × 50.8 cm (16 × 20 in.)
T.2006.59.14

4 *Indiana Street at Brooklyn Avenue, East Los Angeles, June 26, 1987*
Chromogenic print
40.6 × 50.8 cm (16 × 20 in.)
Collection of Devon Susholtz and Stephen Purvis

5 *1553 8th Street, Los Angeles, November 15, 1985*
Chromogenic print
40.6 × 50.8 cm (16 × 20 in.)
T.2006.59.7

6 *600 Shields Drive, San Pedro, September 12, 1992*
Chromogenic print
50.8 × 61 cm (20 x 24 in.)
Collection of Dan and Mary Solomon

7 *100 Block of 7th Street, Los Angeles, October 3, 1980*
Chromogenic print
40.6 × 50.8 cm (16 × 20 in.)
Collection of Devon Susholtz and Stephen Purvis

8 *5200 Maywood Avenue, Maywood, November 2, 1984*
Chromogenic print
40.6 × 50.8 cm (16 × 20 in.)
Gift of Trish and Jan de Bont

9 *719 Lincoln Boulevard, Venice, May 13, 1995*
Chromogenic print
50.8 × 61 cm (20 x 24 in.)
Collection of Rose Shoshana, RoseGallery, Los Angeles

10 *653 Florence Avenue, Los Angeles, April 8, 1990*
Chromogenic print
40.6 × 50.8 cm (16 × 20 in.)
Collection of Michael and Sharon Blasgen

11 *1026 South Indiana Street, East Los Angeles, June 26, 1986*
Chromogenic print
40.6 × 50.8 cm (16 × 20 in.)
T.2006.59.15

12 *5519 East Gage Street, Bell Gardens, February 20, 1986*
Chromogenic print
40.6 × 50.8 cm (16 × 20 in.)
T.2006.59.17

13 *Central Avenue at 20th Street, Los Angeles, November 10, 1985*
Chromogenic print
50.8 x 40.6 cm (20 x 16 in.)
T.2006.59.2

14 *349 Rose Avenue, Venice, July 7, 1980*
Chromogenic print
50.8 x 40.6 cm (20 x 16 in.)
Collection of Michael and Sharon Blasgen

15 *I-405 from 500 Block 33rd Street, Long Beach, June 4, 1980*
Chromogenic print
40.6 × 50.8 cm (16 × 20 in.)
T.2006.59.18

16 *View West from 700 Block, Commercial Street, Los Angeles, April 12, 1987*
Chromogenic print
40.6 × 50.8 cm (16 × 20 in.)
T.2006.59.12

17 *South Central and Washington Boulevard, Los Angeles, March 30, 1984*
Chromogenic print
40.6 × 50.8 cm (16 × 20 in.)
Collection of Wilson Centre for Photography

18 *4801 East Olympic Boulevard, East Los Angeles, February 7, 1980*
Chromogenic print
40.6 × 50.8 cm (16 × 20 in.)
Collection of Dan and Mary Solomon

19 *Carson, November 13, 1979*
Chromogenic print
40.6 × 50.8 cm (16 × 20 in.)
Gift of Jan Kesner and John Humble

20 *View North, I-105 at I-110, Los Angeles, January 15, 1991*
Chromogenic print
40.6 × 50.8 cm (16 × 20 in.)
T.2006.59.1

21 *Headwaters, The Los Angeles River, Confluence of Arroyo Calabasas and Bell Creek, Canoga Park, 2001*
Chromogenic print
50.8 × 61 cm (20 × 24 in.)
2006.10.1
Purchased in part with funds provided by the Photographs Council of the J. Paul Getty Museum.

22 *The Los Angeles River near Victory Boulevard, Reseda, 2001*
Negative, 2001; print, 2006
Chromogenic print
50.8 × 61 cm (20 × 24 in.)
2006.10.20
Purchased in part with funds provided by the Photographs Council of the J. Paul Getty Museum.

23 *The Los Angeles River, Sepulveda Dam Recreation Area, 2001*
Chromogenic print
50.8 × 61 cm (20 × 24 in.)
2006.10.2
Purchased in part with funds provided by the Photographs Council of the J. Paul Getty Museum.

24 *The Los Angeles River, Balboa Boulevard Bridge, Encino, 2001*
Chromogenic print
50.8 × 61 cm (20 × 24 in.)
2006.10.10
Purchased in part with funds provided by the Photographs Council of the J. Paul Getty Museum.

25 *The Los Angeles River, Burbank Boulevard Bridge, Encino, 2001*
Chromogenic print
Sheet: 50.8 × 61 cm (20 × 24 in.)
2006.10.17
Purchased in part with funds provided by the Photographs Council of the J. Paul Getty Museum.

26 *The Los Angeles River at the Glendale Narrows, Atwater Village, 2001*
Negative, 2001; print, 2006
Chromogenic print
50.8 x 61 cm (20 x 24 in.)
2006.10.11
Purchased in part with funds provided by the Photographs Council
of the J. Paul Getty Museum.

27 *The Los Angeles River just above the Arroyo Seco, Los Angeles, 2001*
Chromogenic print
50.8 x 61 cm (20 x 24 in.)
2006.10.9
Purchased in part with funds provided by the Photographs Council
of the J. Paul Getty Museum.

28 *The Los Angeles River from Main Street, Los Angeles, 2001*
Negative, 2001; print 2006
Chromogenic print
50.8 x 61 cm (20 x 24 in.)
2006.10.13
Purchased in part with funds provided by the Photographs Council
of the J. Paul Getty Museum.

29 *The Los Angeles River from Soto Street, Vernon, 2001*
Chromogenic print
50.8 x 61 cm (20 x 24 in.)
2006.10.5
Purchased in part with funds provided by the Photographs Council
of the J. Paul Getty Museum.

30 *The Los Angeles River from Soto and Bandini, Vernon, 1985*
Negative, 1985; print, 2006
Chromogenic print
50.8 x 61 cm (20 x 24 in.)
2006.10.18
Purchased in part with funds provided by the Photographs Council
of the J. Paul Getty Museum.

31 *The Los Angeles River from Downey Road, Vernon*
Negative: 2001, printed 2006
Chromogenic print
50.8 x 61 cm (20 x 24 in.)
2006.10.4
Purchased in part with funds provided by the Photographs Council
of the J. Paul Getty Museum.

32 *The Los Angeles River near Downey Road, Vernon, 2002*
Negative, 2002; print 2006
Chromogenic print
50.8 x 61 cm (20 x 24 in.)
2006.10.16
Purchased in part with funds provided by the Photographs Council
of the J. Paul Getty Museum.

33 *The Los Angeles River at Atlantic Boulevard, Vernon, 2001*
Negative, 2001; print, 2006
Chromogenic print
50.8 x 61 cm (20 x 24 in.)
2006.10.3
Purchased in part with funds provided by the Photographs Council
of the J. Paul Getty Museum.

34 *The Los Angeles River near District Boulevard, Vernon, 1996*
Negative, 1996; print 2006
Chromogenic print
50.8 x 61 cm (20 x 24 in.)
2006.10.19
Purchased in part with funds provided by the Photographs Council
of the J. Paul Getty Museum.

35 *The Los Angeles River from the Atlantic Boulevard Bridge, Vernon, 2001*
Negative, 2001; print, 2006
Chromogenic print
50.8 x 61 cm (20 x 24 in.)
2006.10.14
Purchased in part with funds provided by the Photographs Council
of the J. Paul Getty Museum.

36 *The Los Angeles River from Gage Avenue, Bell, 2001*
Negative, 2001; print 2006
Chromogenic print
50.8 x 61 cm (20 x 24 in.)
2006.10.12
Purchased in part with funds provided by the Photographs Council
of the J. Paul Getty Museum.

37 *The Los Angeles River from the Florence Avenue Bridge, Bell, 2001*
Chromogenic print
50.8 x 61 cm (20 x 24 in.)
2006.10.8
Purchased in part with funds provided by the Photographs Council
of the J. Paul Getty Museum.

38 *The Los Angeles River from Florence Avenue, Bell, 2001*
Chromogenic print
50.8 x 61 cm (20 x 24 in.)
2006.10.6
Purchased in part with funds provided by the Photographs Council
of the J. Paul Getty Museum.

39 *The Los Angeles River from the I-105, Paramount, 1998*
Negative, 1998; print, 2006
Chromogenic print
50.8 x 61 cm (20 x 24 in.)
2006.10.15
Purchased in part with funds provided by the Photographs Council
of the J. Paul Getty Museum.

40 *The Mouth of the Los Angeles River, Long Beach, 2001*
Negative, 2001; print, 2006
Chromogenic print
50.8 x 61 cm (20 x 24 in.)
2006.10.7
Purchased in part with funds provided by the Photographs Council
of the J. Paul Getty Museum.

Up to Now

John Humble

I moved to Los Angeles in the summer of 1974. I intended to stay here for a year, maybe two. I'm still here.

My father was career military, so growing up I lived in Florida, New Mexico, New York, Maryland, Illinois, Georgia, Indiana, California, and Kentucky, as well as Panama, France, and Okinawa.

I studied at the University of Maryland, got drafted, and spent thirteen months in Vietnam as a medic. Went back to college, then got a job as a photojournalist at the *Washington Post*. Determined to pursue my own work, I enrolled in the graduate program of the San Francisco Art Institute. I had a great desire to experience as much of the world as I could, so after the SFAI, I traveled around Europe, through the Middle East, Africa, and Asia, living in my VW van, observing and photographing an amazing variety of landscapes and cultures. After a year and a half, I traded the van for six Turkish carpets in the bazaar in Istanbul, and came home.

So, I moved to L.A. and began teaching and photographing the landscape, one of the most diverse and fascinating that I have ever encountered. I don't think I have to say much about the photographs; they speak for themselves. My images are made with a large-format camera, which allows for great detail and minimizes distortion. Your experience of looking at one of my photographs should be similar to looking through a window.

I never tire of Los Angeles, this great experiment in progress, and the possibilities for my camera are endless. Like Randy Newman, I love L.A.

• • • • • • •

Many people have been a part of my life and, in one way or another, helped to make my images what they are. I'd like to take this opportunity to offer my profound gratitude to all of them.

First, of course, my parents, Mildred and John Humble, who, somehow, miraculously survived my childhood.

Also, Kathi Humble and Kara Humble, providers of assistance and support in countless ways. Kara was instrumental in such tasks as scaring away cows.

My thanks to dear Aunt Emma for her unconditional love, and to Gregg and Marla Wilkins for just putting up with me.

I owe a great debt of gratitude to Peiyi Tu, whose encouragement and critical eye have been invaluable. She always challenges me.

The Philosophy Department at the University of Maryland (circa 1969) for helping me to realize that I know absolutely nothing.

Art Rogers, Jerry Burchard, and Margery Mann at the San Francisco Art Institute, for helping me turn corners and open doors.

Christina Gregory for encouraging me to chart a new course.

I am especially grateful to Jan Kesner for her support, feedback, and tireless efforts on my behalf. She believed in my work when few else did.

I wish to thank the Photographs Council of the J. Paul Getty Museum for their support and their decision to create this book.

There have been many other people who have made their own contributions to my life and work, and I thank them all. You know who you are.

2/3/01

Bridge w/ grafitti, looking
down

Large bridge on left &
then looking down at
grafitti — Both of These
Spring St. Bridge

Similar grafitti, lookin'
down on point of bridge
~~also~~
also a Close up of this.
Both Broadway bridge

Steely looking downtown LA
w/ river, vertical, just
S. of 1st St. Bridge

2/3/01

Later in day, 4, wide river,
Sun on left & trades there,
bridge on right. This
from 26th St. Bridge Vernon

Very wide river, Lots of it
w/ river running between
2 rails. They were golden
when I got there, but
Last shot at 5 pm they're
Not golden, maybe 4:30?
Downey St

2/4/01

Beginning of the river
Bell Creek + calabasas
Kings canoga Park
Big devider looming

Technical Notes

John Humble

I used several Cambo cameras designed to utilize four-by-five sheet film. The lenses were Schneider and Rodenstock lenses. Early on the film was Kodak Ektachrome, a transparency film. I printed those on Cibachrome, an extremely demanding process. Since that material is very contrasty, and I didn't want contrasty prints, I had to make a contrast mask for each image. This consisted of exposing Kodak Pan Masking film in contact with the transparency, then developing and drying the film. The mask and the transparency had to be in registration when you made the mask and when you printed, so I made my own registration system.

I also had to print between two pieces of glass to keep the mask and transparency tightly in contact, so that meant two things; first, I had eight surfaces to keep dust free when I exposed the Cibachrome material. Second, shiny surfaces in contact with each other produce Newton Rings, rainbow-like colors in the print (even with Anti-Newton glass). So, I finally got some printer's dust, which I would spray into the air, and let just a few grains fall onto the mask. This prevented the glass from touching the film surface.

The Cibachrome chemical process itself was also demanding. I printed each print separately, using a tube to contain the print and the chemicals and a motor to roll it back and forth. The process consists of three chemical steps and a water wash. The bleach part of the process in a very potent acid, and it was necessary to use rubber gloves and make sure that no bleach got on my skin. To be disposed of, the bleach had to be neutralized, creating a terrible odor. I printed wearing rubber gloves and an industrial respirator and placed a huge fan over the sink to try to eliminate the odor.

I eventually started teaching at a school that had a large color-print processor, but it would only process prints from negatives. I took my transparencies to a lab and had inter-negatives made, that is, negatives made from the originals. I then began to print my work at school, a much simpler and more efficient (and less dangerous) process and made the switch to color negatives. The original film was Kodak VPS, and I eventually began using the film I use now, Kodak 160NC.

I make most of my own prints up to 20 x 24. Larger prints are made by a commercial lab, using a Lightjet printer. In this process, the negative is scanned (either by me or the lab) and the subsequent digital file is printed on the Lightjet using lasers that scan the photographic paper with three discrete beams of light (red, green, blue); then the paper is developed in the traditional chemicals. All of the prints for this exhibition and book are dye-coupler (chromogenic) prints.

I found my images by driving around L.A. (and vicinity), looking out the window of my VW van. I had a platform on the top and made a good number of photographs from there. I went through several vans doing this.

Editor: John Harris
Designer: William Longhauser
Assistant Designer: Christopher Saltzman
Production Coordinator: Stacy Miyagawa
Photographers: Gary Hughes, Michael Smith,
Stacey Strickler

Printer: C S Graphics, Singapore
Color Separator: ProGraphics, Rockford, Illinois

Initial RGB image captures of the Humble
photographs were made on a Cruse scanner.
The images were then converted to CMYK
separations and printed 200-line screen on
Lumi Silk 150 gsm.